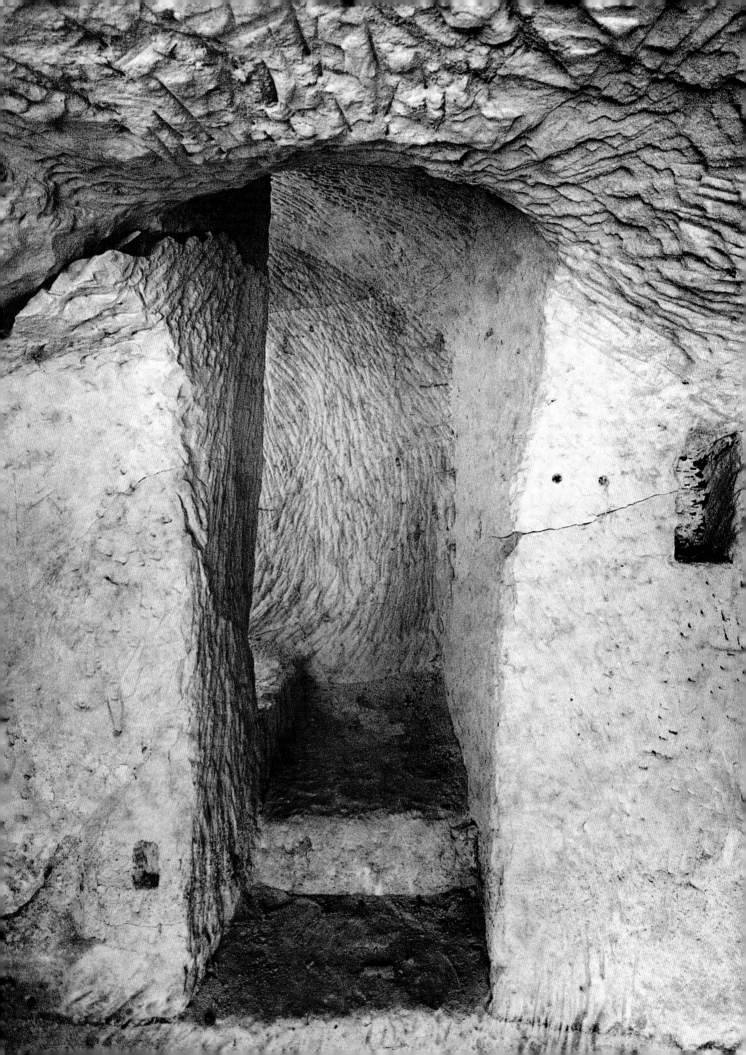

QUALITY IN PHOTOGRAPHY

HOW TO TAKE, PROCESS AND PRINT EXCELLENT PHOTOGRAPHS

ROGER HICKS AND FRANCES SCHULTZ

David & Charles

FOR COLIN GLANFIELD 1934–1999
THANK YOU

A DAVID & CHARLES BOOK

First published in the UK in 2000

A catalogue record for this book is available from the British Library.

ISBN 0 7153 0990 0

Designed by Bruce Low

and printed in Singapore by C S Graphics Pte for

David & Charles
Brunel House Newton Abbot Devon

FRONTISPIECE
ABANDONED TROGLODYTE HOUSE, GOZO
*Quite honestly, we could have taken this picture – which is one of our favourites of all time –
with almost any camera we own, provided we used a tripod and metered carefully to get
adequate shadow detail. The key to quality, ultimately, is passion: after that, all you need is a
reasonable grasp of technique, and reasonable care in execution.*
TECHNICAL INFORMATION CAN BE FOUND ON PAGE 125. (FES)

CONTENTS

■ ■ ■

CHAPTER ONE

UNDERSTANDING QUALITY

Quality is not an absolute. A picture may be adequate (or even superb) for one purpose, but quite inadequate for another. A picture which reproduces beautifully may well be disappointing as an exhibition print; a magnificent exhibition print is often equally disappointing in reproduction. A picture which is truly magical at postcard size may 'fall apart' when it is enlarged; but another picture, unremarkable as a postcard, may be very striking indeed at poster size.

Also, quality is easier to recognize than to analyse. We all know photographers whose prints are technically superb, but curiously lifeless and formulaic. We know others who have a superb 'eye', but who are lazy or incompetent when it comes to technique. And most of us have seen prints which fairly exuded quality, without our understanding quite how or why.

Perhaps the first point is that quality must be appropriate. It is most appropriate when it is least apparent; in other words, a picture must succeed as a whole, without technical quality taking precedence over content, composition, and all the other things which go to make up a picture. If it evokes the reaction, 'Great picture, shame about the technique,' then clearly the photographer has not fully succeeded; but if the reaction is, 'Technically superb, but...' then the photographer has equally fallen short.

As a general rule, for obvious reasons, it is better to have too much technical quality, rather than too little: a picture that is technically better than needed is clearly preferable to one that is technically inadequate. This is where the concept of the 'quality threshold' comes in.

This is the level below which, by any reasonable standard, quality is inadequate. Obviously, it varies. If you only ever shoot postcard-sized prints for the family album, you are placing fewer demands on your camera, lens, film and technique than if you habitually produce 16x20in (40x50cm)

BRIDGE, ZUERICH
Most decent cameras are above the 'quality threshold', though few are as far above as the Alpa 12 WA with which this was taken. Most materials and chemistry, likewise, will deliver excellent quality. All you normally have to do is to follow the manufacturers' instructions: this was Ilford HP5 Plus, developed in Paterson FX39 and printed on Ilford MG Warmtone, then partially toned in Paterson sepia. The main things are holding the camera level and pressing the shutter release at the right time.
CAMERA HAND-HELD, 38/4.5 BIOGON, 44X66MM. (RWH)

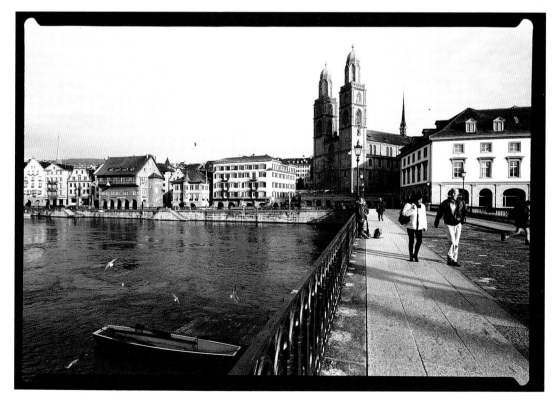

exhibition prints. The quality threshold can therefore be correspondingly lower. Also, it is undeniably true that almost any technical shortcoming can be turned into an asset, in the right picture.

Even for exhibition prints, though, the quality threshold can be reached surprisingly affordably. For example, we have a brace of Pentax SV cameras from the 1960s, with contemporary lenses. Modern 35mm cameras may (or may not) be easier to use, but very few will deliver better quality. Many will not even be as good. And one of the finest photographers we have met is a retired submarine commander, living in Moscow, whose ancient Mamiya roll-film cameras might well be relegated to the junk shelf in most camera stores.

The same photographer – Rustam – produced stunning prints on paper so old that he had to add generous quantities of benzotriazole to the developer to stop it fogging. This led to very long exposure and development times, but the prints were (and are) still superb. Equipment and materials should not, then, prove a barrier: technical and artistic skill are what matter. So how can they be cultivated?

THE VALUE OF PRACTICE

To a very large extent, both technical and artistic skill depend on practice. If you have a few hundred pounds, dollars or euros which you can

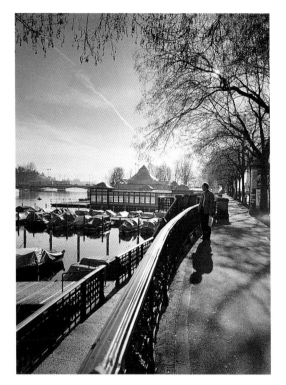

BACKLIGHTING, ZUERICH
This is, believe it or not, a snapshot with a guessed exposure. The exposure was guessed because Roger had not realized we were going to be loaned the Alpas that day, and had not brought even an exposure meter, let alone a tripod. But with medium-format colour negative film, there are no great penalties for over-exposure. It is a snapshot because he had to shoot fast before the man on the right moved. Frances is in shot on the staircase to the left of him.
ALPA 12 WA, 58/5.6 SUPER ANGULON ON 6X8CM, KODAK VERICOLOR.

afford to spend on photography, you will almost invariably do better to spend it on film, and on going somewhere to take pictures, than on 'upgrading' cameras and lenses.

While it is (of course) true that some cameras and lenses are better than others, and while Chapters 3 and 4 deal with these very questions, it is equally true that the vast majority of

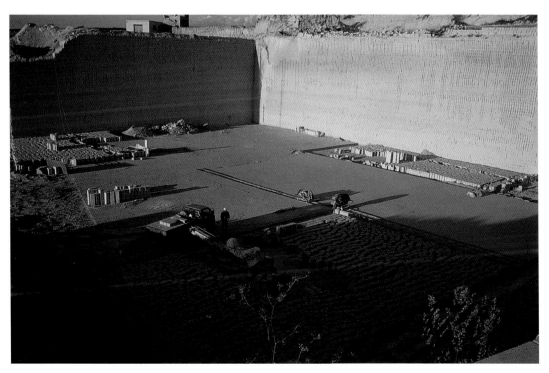

QUARRY, GOZO
Never be afraid to 'waste' a few frames on a subject which might not work out. You may get lucky, and even if you don't, you will have learned something about how your camera, lens and film perform in a given set of circumstances. It is always worth making an effort to finish the last few frames of a film on experimental subjects, rather than letting it sit in the camera.
HAND-HELD LEICA M2, 35/1.4 SUMMILUX, FUJI ASTIA (RWH)

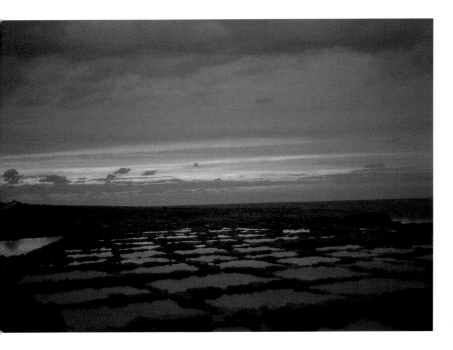

SUNSET AND SALT PANS, GOZO

A 'kickself' picture. The light was gorgeous; the reflections in the salt pans were fascinating. Roger mistakenly believed there would not be time to get out a tripod. As a result, there is some camera shake, and depth of field is inadequate. A light, fast-acting tripod is an essential accessory for many pictures, and desirable for almost all.
LEICA M2, 35/1.4 SUMMILUX, FUJI RA. (RWH)

SETTING SUN, MALTA ▶
The classic advice for getting good press pictures was 'A sixtieth at f/8 and be there.' Well, this was more like ⅕ at f/8 but the advice to be there was just as important: we hung around on the hill for almost an hour as the sun set, watching, and shooting, the changing light.
LEICA M2 ON TRIPOD, 35/1.4 SUMMILUX, FUJI RA. (RWH)

photographers never push their equipment to its limits. Until you genuinely know that you are being limited by your equipment, and understand why, there is absolutely no point in 'upgrading'; unless, of course, you feel that sheer pride of ownership might make you try harder. This should not be neglected: trying to 'live up' to a Contax or an Alpa or a Gandolfi can be quite a spur to improvement.

The great thing about practice is that you can improve the aesthetic side of things – your 'hit rate' of successful images goes up steadily – while at the same time constantly refining your technique. If a roll of film lasts you ten days, then the things that you did right and wrong, the way you shot a particular picture, cannot be as fresh in your mind as they would be if you finished the roll and processed the film immediately. And if you shoot five rolls in a week (or a month), then you should learn more, and faster, than if you shoot just one.

TIME AND MONEY

It is never easy to fit a serious commitment to photography around a busy life in which you have to earn a living, run a household and maybe raise children as well; but equally, you might be surprised, if you stopped to think about it, at how little extra it will cost you, in either time or money, to take your photography a bit further.

In particular, instead of letting the last few

frames sit in the camera, shoot them off. Try new techniques: very long time exposures, double exposures, heavy filtration. Shoot the same subject hand-held, and with the camera on a tripod, and see what difference it makes to sharpness. Look for deliberately 'off the wall' subjects: semi-abstracts, ultra close-ups. Zoom during exposures. Shoot brick walls, to test resolution and distortion. The possibilities are endless, and not only will you learn more about things you had not previously tried; you will also have things fresh in your mind when you see the pictures.

Of course, if you like the results you get, you can end up spending a lot more time and money on your photography. We ended up earning our living from it. But even if you never see a penny back in financial terms, you can still get a tremendous return on your investment, little be it or much, in sheer enjoyment.

LEARNING ABOUT QUALITY

Practice alone can teach you an enormous amount about quality, but you can learn faster and better if you combine practice with two other

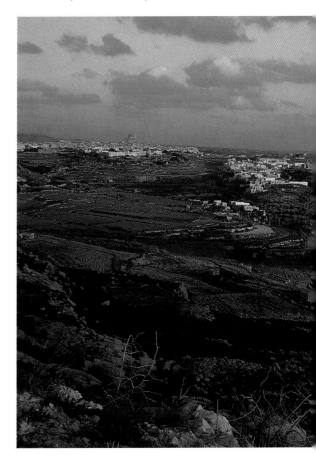

approaches. One is trying to understand the theory behind what you are doing, and the other is looking at as many original prints as you can.

Theory is dry and irrelevant on its own, but it really comes to life when you see its relevance in your own pictures, and in others' pictures. To a very large extent, this is a book of theory; but it is, we hope, a book in which theory and practice are intertwined to an extent that will make you want to understand both better.

PICTURES AT AN EXHIBITION

The important thing about original prints is that they can show you interpretations of quality that you will never get from reproductions. An original print can hold a far wider range of tones, far more subtly, than even the best photomechanical reproduction; until you have studied a wide range of original prints, you will never understand what quality can really mean.

The prints need not be by great photographers, though equally, if they are, the pleasure is greater; but even a local camera club exhibition can turn up prints which fairly take your breath away

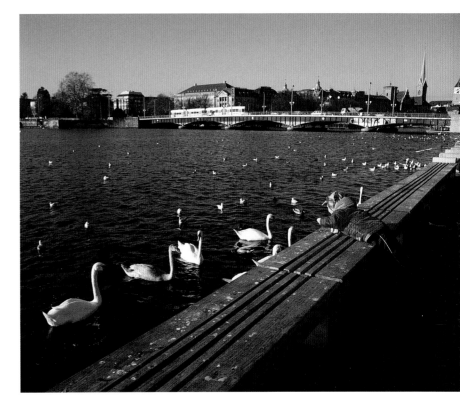

technically, whether or not they are aesthetically remarkable. The same exhibition may also provide ghastly examples of techniques to avoid, or of techniques improperly realized, which can be another useful lesson.

You may however be surprised if you see original prints by 'Great Photographers', which hitherto you had seen only in reproduction. Some will have a lambent quality which was barely hinted at in the reproductions, while others may be surprisingly poor. Even the great Ansel Adams is not immune from this criticism: some of his Hasselblad pictures were, without doubt, over-enlarged for exhibition, and look a lot better on the printed page.

Another important point about seeing original prints is that they are the only way in which you can appreciate so-called 'alternative' processes. These can have a charm that is all their own, but if you only ever see them in reproduction, they normally look like inferior versions of conventional silver gelatine prints.

THE PAINTED WORD

Looking at pictures is one thing, but reading about them is quite another. Photography is a visual medium, and must stand as such. If a photograph

CHILD AND SWANS
Can you have too much quality? Arguably, yes. This is a charming snapshot, but thanks to the equipment and film used (hand-held Alpa 12WA, 58/5.6 Super Angulon on 6x8cm, Kodak EPL) it is arguably too slick, too 'chocolate boxy'. A 35mm compact with colour negative film might have removed the temptation to make an exhibition print from it. (RHW)

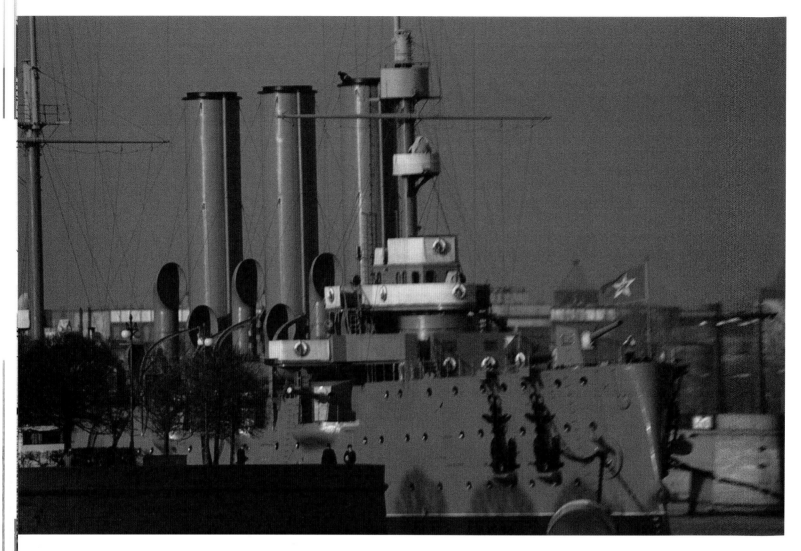

CRUISER AVRORA, SANKT PETERSBURG

If you want very long lenses – this was shot with an 800mm f/11 Vivitar 'Solid Cat' – then 35mm is the only choice: an equivalent lens on 6x7cm would be about 1700mm. On the other hand, the quality attainable with such lenses is often marginal, except under ideal conditions: this picture could be sharper, and it is redeemed only by the light and by the historical associations of this ship.
NIKON F ON TRIPOD, FUJI RF. (RWH)

And the cameras are reasonably light, they are also reasonably compact – the Aria is very compact – and ergonomic in layout.

Better yet, they are part of a full system which embraces both fully mechanical cameras (the S2, though this is now sadly discontinued) and an autofocus camera (the AX), though we have yet to find a use for the latter. No other high-end systems offered this sort of range; we have always had the uncomfortable feeling that we would be locking into a system which was designed by engineers who were more concerned with technological possibilities, rather than with what photographers actually wanted or needed. We were also worried about buying into a system which was here today, gone tomorrow; or where the lens mount might suddenly change; or where only autofocus lenses were available.

Best of all, the Contaxes' quality is second to none. Many of the Zeiss lenses are made in Japan,

though a few (such as the 35mm f/2.8 PC-Distagon) are still made in Germany. Regardless of where they are made, the quality of both bodies and lenses is superlative.

Having said all this, we have to acknowledge that once you are past the 'quality threshold' mentioned on page 8, the advantages of the latest and the best are not great, as compared with choice of materials and technique. In other words, if your budget is small, buy something like our old Nikons or Nikkormats, or even screw-fit Pentaxes. You will lose some versatility, and some convenience; but provided you stick with the right lenses, which are the subject of the next chapter, you will sacrifice little or nothing in the way of quality.

If you can afford it, on the other hand, the best cameras today will entail absolutely no loss of quality or versatility compared with the very best designs of the past, and will be a lot more

approaches. One is trying to understand the theory behind what you are doing, and the other is looking at as many original prints as you can.

Theory is dry and irrelevant on its own, but it really comes to life when you see its relevance in your own pictures, and in others' pictures. To a very large extent, this is a book of theory; but it is, we hope, a book in which theory and practice are intertwined to an extent that will make you want to understand both better.

PICTURES AT AN EXHIBITION

The important thing about original prints is that they can show you interpretations of quality that you will never get from reproductions. An original print can hold a far wider range of tones, far more subtly, than even the best photomechanical reproduction; until you have studied a wide range of original prints, you will never understand what quality can really mean.

The prints need not be by great photographers, though equally, if they are, the pleasure is greater; but even a local camera club exhibition can turn up prints which fairly take your breath away

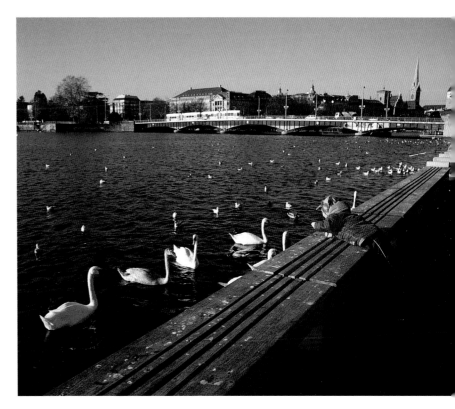

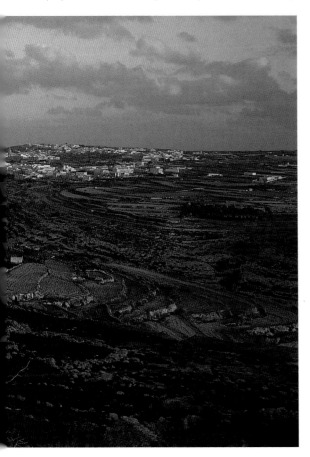

technically, whether or not they are aesthetically remarkable. The same exhibition may also provide ghastly examples of techniques to avoid, or of techniques improperly realized, which can be another useful lesson.

You may however be surprised if you see original prints by 'Great Photographers', which hitherto you had seen only in reproduction. Some will have a lambent quality which was barely hinted at in the reproductions, while others may be surprisingly poor. Even the great Ansel Adams is not immune from this criticism: some of his Hasselblad pictures were, without doubt, over-enlarged for exhibition, and look a lot better on the printed page.

Another important point about seeing original prints is that they are the only way in which you can appreciate so-called 'alternative' processes. These can have a charm that is all their own, but if you only ever see them in reproduction, they normally look like inferior versions of conventional silver gelatine prints.

THE PAINTED WORD

Looking at pictures is one thing, but reading about them is quite another. Photography is a visual medium, and must stand as such. If a photograph

CHILD AND SWANS
Can you have too much quality? Arguably, yes. This is a charming snapshot, but thanks to the equipment and film used (hand-held Alpa 12WA, 58/5.6 Super Angulon on 6x8cm, Kodak EPL) it is arguably too slick, too 'chocolate boxy'. A 35mm compact with colour negative film might have removed the temptation to make an exhibition print from it.
(RHW)

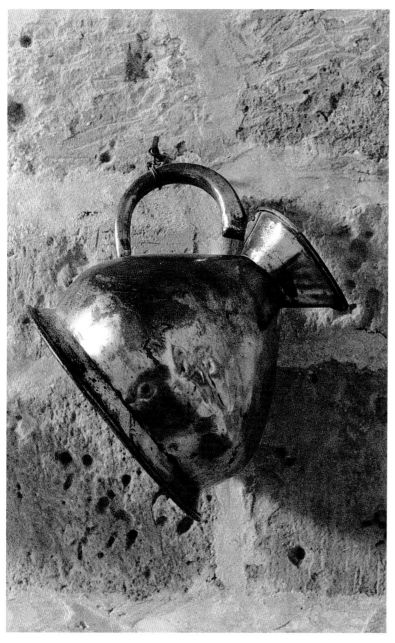

often rather different. A well-made monochrome print has a wonderful, and very extended, range of tones which range from a clear, paper-base white to a deep, rich black. The actual brightness range of the print may exceed 200:1, a density range of 2.3 or about 7½ stops.

In colour, while it is possible to capture an equally wide tonal range, pleasing colours can only be represented across a brightness range of at most 32:1, a density range of 1.5 (5 stops). Very light tones tend to turn into shades of yellow, and very dark tones into browns, so unless the lighting is under the photographer's control, there may well be significantly larger areas of blocked-up shadow detail than there would be in a monochrome print of the same subject. It is often impossible to favour the shadows any more, because this would lead to unpleasantly large areas of burned-out highlights.

A great deal of the appeal in a colour photograph therefore tends to reside in the use of colour, and of broad areas of light and dark. In monochrome, the length and subtlety of the tonal range is often the most noticeable aspect of quality, and sharpness and detail may also be more relevant than they are in colour. There is also more scope for dramatic lighting in black and white. But heresy though it may be to say it, there are two things which can be more important than any of this. They are content and composition.

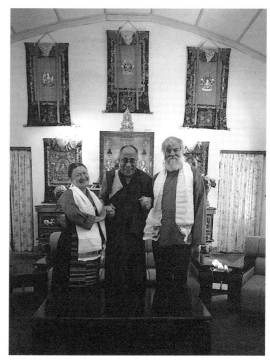

COPPER JUG
Grain does not automatically preclude quality. When Kodak TMZ P3200 was the only ultra-fast film available, we loved it. Then Ilford Delta 3200 came along, with ⅓ stop more speed and vastly better tonality.

The true specular highlights on this polished copper are going to 'blow' no matter what you do, but otherwise, the tonal range is extraordinary.
CONTAX RX ON TRIPOD, 100/2.8 MAKRO-PLANAR, PRINTED ON ILFORD MG IV SEQUENTIALLY TONED IN SEPIA AND GOLD. (FES)

requires endless explanation, analysis and criticism, you have to ask yourself why. The answer, all too often, is that it has nothing to say on its own, or in other words, that it is not much good as a photograph. Tom Wolfe's *The Painted Word* is a trenchant commentary on art criticism; many of his observations are equally applicable to photography.

MONOCHROME AND COLOUR

One more point is worth making, while we are talking about learning to recognize quality. It is that the criteria for colour and monochrome are

CONTENT

The vast majority of pictures are valued, above all, for their content. This is true whether you are a grandparent looking at photographs of your new grandchild, an armchair traveller looking at pictures of some remote destination, or a news editor looking at a picture of a princess kissing a playboy. The news example is deliberately left until last because, in the real world, it has the least

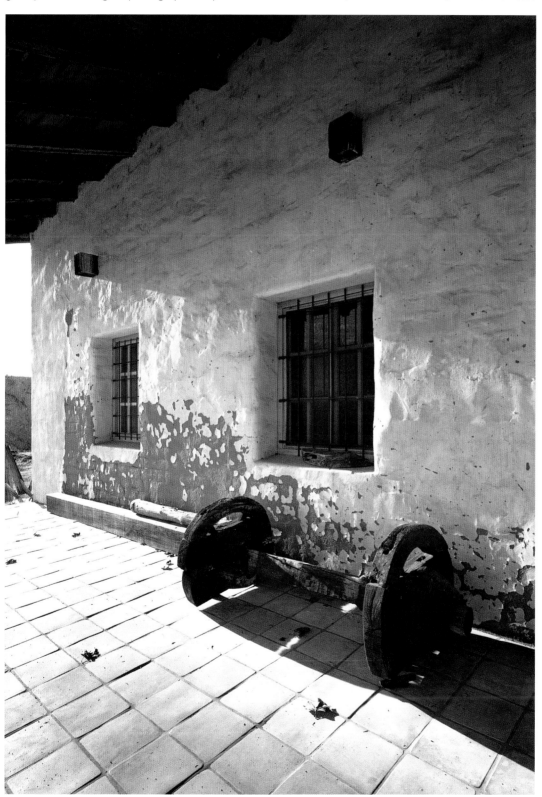

MISION SAN ANTONIO, CALIFORNIA
In monochrome, the single most important factor is exposure. Here, the aim was to hold detail in the roof beams and on the side of the wheel: limited-area readings made sure that they did not block up into feature-less black, though the detail may not be visible in reproduction. After that, the important point was not to overdevelop and 'blow' the highlights; there is even a tiny bit of tone in the sky on the left.
ALPA 12 WA HAND-HELD, 38/4.5 BIOGON ON 44X66MM, ILFORD 100 DELTA PRO PRINTED ON ILFORD MG WARMTONE TONED WITH SELENIUM. (RWH)

◀ **HH DALAI LAMA**
This is not the sharpest picture in the world, but it is very precious to us: His Holiness was much amused by Roger's monocle, and insisted that he put it in for the picture. Ultimately, content must always take precedence over technical quality. The picture is also a classic example of stupidity on our part: we should have thrown away the unexposed roll of Ilford HP5 Plus in the camera and replaced it with Delta 3200, for extra depth of field and a higher shutter speed.
ALPA 12 WA HAND-HELD, 38/4.5 BIOGON ON 44X66MM, TENZING GEYCHE

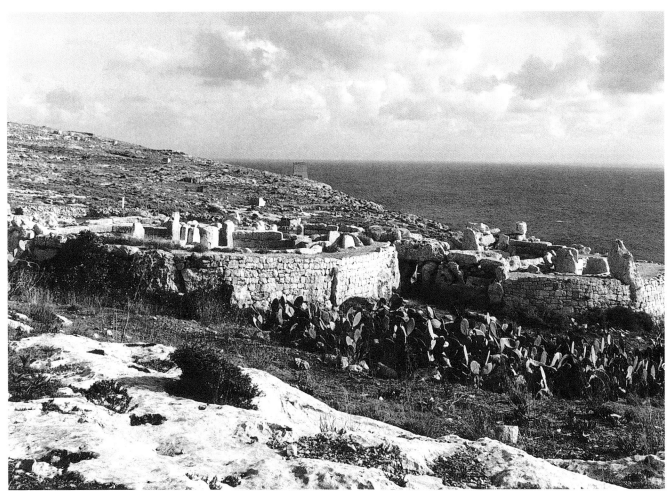

MNAJDRA, MALTA
We both have a great weakness for historical subjects, and love to explore the textures and shapes of ancient buildings. These temples at Mnajdra are about as old as they come – they are roughly contemporaneous with the Pyramids of Gizeh – and Frances shot them on Ilford SFX using an infra-red filter.
CONTAX RX ON TRIPOD, 100/2.8 MAKRO-PLANAR.

enduring importance: it will be thrown away with the day's paper, while the family pictures will be kept forever, or as close to forever as human lives and family histories permit, and even the travelogue may well be read again and again.

In all of the above cases, and in many others, quality takes second place to content. As long as the subject is reasonably recognizable (and reasonably interesting), no one is too fussed about grain and tonality or many of the other things which photographers normally worry about. This is a sobering and salutary reminder.

On the other hand, concern for content by no means precludes quality. If the news photographer could duplicate the pose of Rodin's *The Kiss*, while still ensuring that at least the princess (and preferably the playboy) remained recognizable, it would be a better picture than a blurry, grainy picture taken with an ultra-telephoto lens.

If, however, the people or places involved are not inherently interesting, or for that matter if the subject matter is overly familiar, then technical quality can be very important. A good

photograph reveals its subject as if for the first time, and technique can be a key to this. But so can passion.

PASSION

A point widely ignored by writers on photography, despite its fundamental importance, is that few people take good pictures – that is, pictures which succeed as pictures, rather than as record shots – unless they have some interest in the subject. It is not enough to try sports photography unless you like sports, or portraiture unless you really want to photograph people. 'Passion' may be an exaggeration, but equally, the best pictures are often taken by people who are passionate about their subjects.

It is true that you can come to be fascinated by a subject as a result of trying to photograph it, but it is also true that you can quite easily confuse your feelings about a subject with your feelings about photographs of it. You can then waste a lot of time in trying to emulate photographers whose

work you admire, without realizing that you have no real sympathy with what they photograph.

We did exactly this with landscapes. There are countless superb photographers in the United States who take as their text the unspoiled wilderness, or something that looks like it. We both wasted a good deal of time in trying to emulate them, before we accepted that both intellectually and aesthetically, we are more inclined to the eighteenth-century view that man shapes and gives meaning to the landscape. We are therefore happier photographing ancient buildings, terraced fields, prehistoric ruins, handsome cityscapes, mediaeval villages, and even workshops and factories; and we get better pictures this way.

The view – again common in America – that man can only despoil and ruin the planet is very much a product of a particular place and (still more) of a particular time. There always have been, and still are, those who can harmonize the natural and the man-made. We prefer to celebrate them, rather than to ignore them or to deny their existence.

COMPOSITION

Like content, composition can transcend technical quality. Some people can arrange shapes, tones or colours in a way which is so inherently attractive that sharpness and grain and the like take a very subordinate place.

Even so, technical quality is often important. A picture that is well composed and potentially attractive, but lacks technical quality, can be a painful reminder of what might have been. Initially, the lack of technical quality may not seem to matter, but sooner or later it will start to niggle. This is especially true of one's own work.

We have written more about composition in Chapter 7, where we have described it as a non-photographic skill, which it is: the overall techniques of composition, of handling shapes and colour and light and shade, are as applicable to drawing or painting as they are to photography. With this in mind, it is time to begin to look at the technical side of quality, and in particular at sharpness and resolution, tonality and colour.

BARRELS, FORT SCOTT, KANSAS
We shot this in about 1991 for a book – which came to nothing – on the American Civil War, a sequel to our Battlefields of the Civil War (1989). It shows how wide-angles have to be used with care and discretion, if one is to avoid give-away distortions: this, like everything else in the photographic process, is a link in the chain of quality.
NIKON F ON TRIPOD, 14/3.5 SIGMA. (FES)

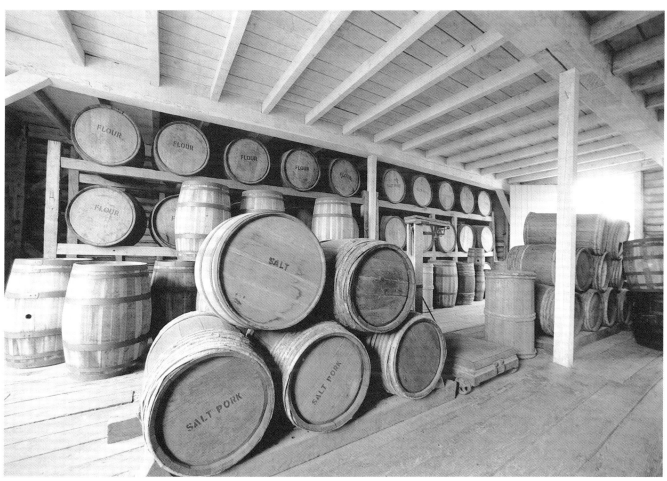

CHAPTER TWO

TECHNICAL QUALITY

MONK WITH PRAYER WHEEL, BIR

Biting sharpness in the skin and beard textures is an essential part of this picture: Frances used a 100/2.8 Makro-Planar on a Contax RX to ensure it. Ilford XP2 Super allowed a reasonably short hand-held exposure, at the expense of a slight loss of depth of field (look at his right hand). He is looking at a Polaroid of himself that we have just given him.

Sharpness and resolution are an obvious starting point for any consideration of quality, before we go on to look at tonality and colour. Although they are intimately related, sharpness and resolution are not the same thing; and both are equally intimately intertwined with the question of film grain, which is covered in Chapter 6.

We are concerned here with what looks sharp, and there are a distressing number of variables. Visual acuity varies from person to person, even with corrected vision (if necessary). Viewing distance is critical: a picture that looks sharp at arm's length may not look so sharp when it is examined close up. It is quite possible to have a lens of high sharpness and a film of modest sharpness, or vice versa: it is of course desirable that both should be as sharp as possible. And the sharpest films do not always have the most pleasing tonality.

The traditional argument about viewing distances is that bigger pictures are normally viewed from further away. This would make the problem self-solving, but to a very considerable extent, it is simply untrue. A really good photograph is a 'magic window': it invites the viewer into its own miniature world, like Alice through the looking glass. People may start off looking at it from a distance, but they are drawn closer and closer, until they end up with their noses a mere hand-span from the print.

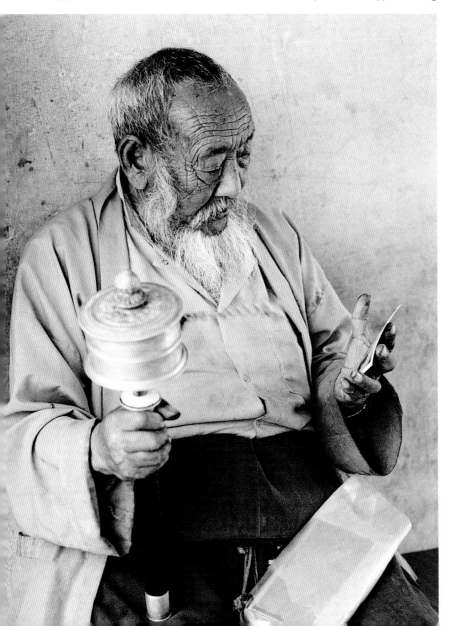

SHARPNESS

Sharpness is a measure of the transition between a light area and a dark area. The clearest example is the 'knife edge' test. Where the emulsion is covered by the knife, it should be clear, because no light has reached it. Where the emulsion is uncovered, it should darken. With a perfectly sharp emulsion, the gradient between the two would be a sudden cut-off, a right-angled step.

In the real world, there is an S-shaped gradation between the two areas. This is caused by the scattering of light within the emulsion, which is one reason why thin emulsions are generally preferable to thick ones. If the gradation is too gradual, then fine detail will lose contrast and may even disappear altogether: the centre of a sufficiently thin line may simply fail to reach an adequate density to differentiate it from the surroundings, and the edges will diffuse into the background. This micro-contrast or edge-contrast is commonly known as 'acutance', a term coined by Higgins and Jones of the Kodak research laboratories in the 1940s.

There are a number of ways to improve sharpness. Obviously, a sharp lens helps. So does a

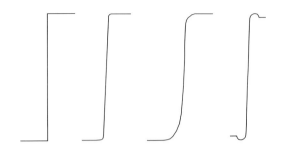

sharp, thin-emulsion film. Acutance developers are discussed at greater length in Chapter 9. A very simple route, though, is to use a bigger image. If a bar that is 10mm (0.4in) wide is projected on to the film as a line that is 0.5mm (1/50in) wide, then it is unlikely to disappear; but if it is only 0.05mm (1/500in) wide, it may well disappear as a result of low acutance, high grain, or poor film resolution – or, for that matter, because of poor lens resolution and flare (see Chapter 4).

SHARPNESS
The drawing on the left represents 'perfect' sharpness: a clean, sharp transition from light to dark. The two centre drawings show what happens in the real world: a slight 'bleeding' of the boundaries, so that the transition is S-shaped rather than square. The left centre film exhibits higher acutance than the right centre. Finally, the drawing on the right shows the use of edge effects (via developer exhaustion) to accentuate acutance. This is a useful trick, but taken to extremes, it can look unnatural.

◀ NEAR MARSAXLOKK, MALTA
This was a deliberate experiment with Fuji Velvia, a very saturated, contrasty film, in bright sunlight. A half stop less exposure blocked up the shadows hopelessly; a half stop more 'blew' the high-lights to a featureless white. The picture is very dramatic – but a more forgiving film would have made life a lot easier, and it is generally a good idea to learn on the easiest materials available, rather than the most difficult. 'BABY' LINHOF TECHNIKA IV ON TRIPOD, 100/5.6 APO-SYMMAR ON 6X7CM. (RWH)

ZUERCHER ZEE
*The 6x8cm format –
actually 56x76mm, as
espoused by Mamiya –
deserves to be more
popular, as it fits beautifully
on to A4 and allows a
useful 9-on-120 instead of
the 8-on-120 of 6x9cm.
Next to 6x8cm, 6x7cm
can look uncomfortably
stubby, and 6x9cm looks
too long and thin. The
actual aspect ratios are
1:1.2 (most 6x7,
56x68mm), 1:1.3 (Linhof
6x7, 56x72mm), 1:1.4
(6x8cm) and 1:1.5
(6x9cm).*
ALPA 12WA HAND-HELD, 58/5.6
SUPER ANGULON, KODAK
EKTACHROME 100EPP. (RWH)

Leicas. The Nikons dated from the late 1960s; the Nikkormats, Nikon's second-string cameras, from the 1970s; and the Leicas are M-series range-finder cameras which first appeared in the 1950s, though we have two M2 cameras from the 1960s, and an M4-P from the 1980s.

Because Nikon's lens mounts have remained cross-compatible from 1959 to the present, and the M-series Leica's is unchanged since 1954 or so, immense numbers of first-class lenses are available for either. Among the simpler designs, lenses which are several decades old can be entirely satisfactory; and exotic new designs, such as Sigma's 14mm rectilinear-drawing wide-angle, are normally made available in Nikon fit from their introduction.

Although we have remained faithful to range-finder Leicas – actually, these are Roger's pre-ferred cameras in 35mm – we have now switched to the second approach, which is to use the latest and the best; which, in our opinion, are unques-tionably Contax reflexes.

We came to this conclusion for a variety of reasons. The original, and (as it turned out)

The first approach is a lot cheaper. It depends on the simple (and unanswerable) truth that a camera is essentially a dark box for holding film, with a hole in the front for holding lenses, and a shutter in between. As long as the film transport and shutter work; as long as the film and the lens flange are the right distance apart; and as long as you can fit good lenses on the front, then you need nothing more.

There are innumerable reliable cameras which meet all these criteria, many dating back to the 1960s and some even going back to the 1950s. We have already mentioned our Pentaxes, but in fact our main cameras were Nikons, Nikkormats and

actually the least pressing advantage, was that we wanted to try the focus confirmation system of the RX. We have yet to encounter any autofocus camera which could replace our old manual-focus machines: they are too big, too heavy, and too complicated, and they simply fail to focus too often, though the latest models are vastly superior to the earlier ones. But ageing eyes sometimes need help.

As soon as we started to use the Contaxes, a number of features commended themselves. Although the classical shutter speed range of I second to $\frac{1}{1000}$ second is adequate for the vast majority of applications, especially reportage, the extended range of the Contaxes (4 seconds to $\frac{1}{4000}$ second on the RX) can be useful in ultra-low light or with very fast films. Auto-bracketing, with a fast, built-in motor drive, is ideal for film testing or simply for trying different exposures. Unlike most other modern cameras we have tested, the Contaxes never throw us into strange program loops where we needed to read the instruction book to reset the camera: the controls are simple, logical, and self-evident.

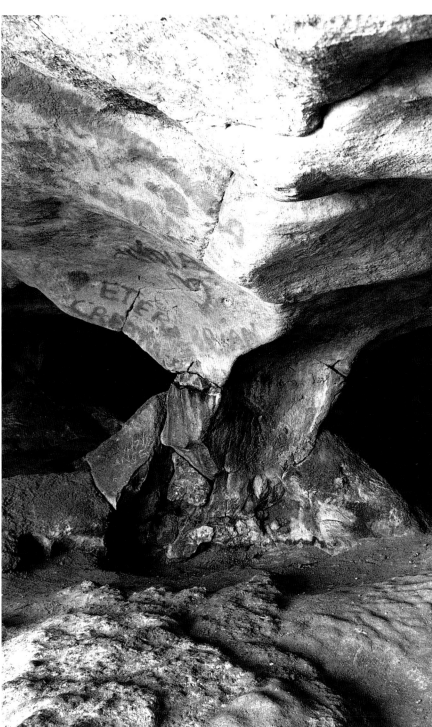

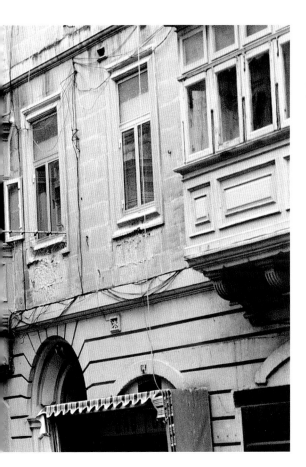

VALETTA
There are a few – a very few – medium-format cameras which would allow you to take grab shots like this, but even if you had one, you would be troubled by lack of both lens speed and depth of field. For these purposes, 35mm is a much better bet.
CONTAX ARIA HAND-HELD, 100/2.8 MAKRO-PLANAR, ILFORD XP2 SUPER. (FES)

▲ HASSAN'S CAVE
Use 35mm in the same way as you would use large format, and you may be amazed at the quality it can deliver. Frances used a 35/2.8 PC-Distagon on a Contax RX, tripod-mounted of course, and Ilford XP2 Super to record this cave (and, sadly, the graffiti in it).

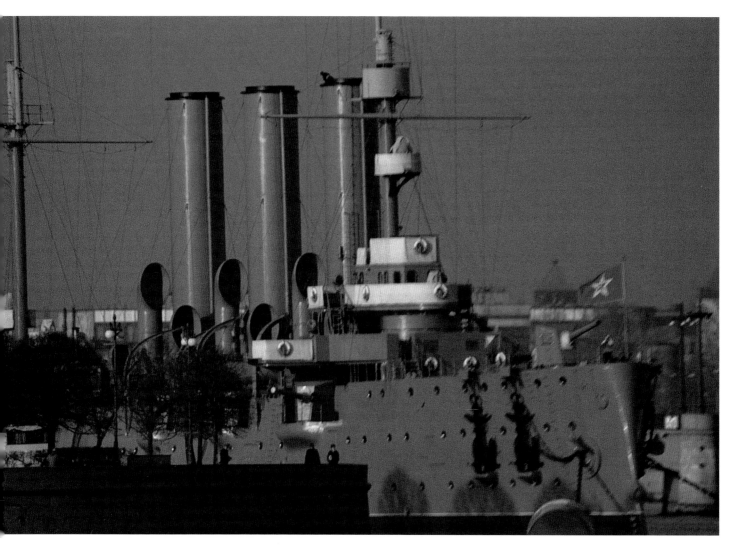

CRUISER AVRORA, SANKT PETERSBURG

If you want very long lenses – this was shot with an 800mm f/11 Vivitar 'Solid Cat' – then 35mm is the only choice: an equivalent lens on 6x7cm would be about 1700mm. On the other hand, the quality attainable with such lenses is often marginal, except under ideal conditions: this picture could be sharper, and it is redeemed only by the light and by the historical associations of this ship.
NIKON F ON TRIPOD, FUJI RF. (RWH)

And the cameras are reasonably light, they are also reasonably compact – the Aria is very compact – and ergonomic in layout.

Better yet, they are part of a full system which embraces both fully mechanical cameras (the S2, though this is now sadly discontinued) and an autofocus camera (the AX), though we have yet to find a use for the latter. No other high-end systems offered this sort of range; we have always had the uncomfortable feeling that we would be locking into a system which was designed by engineers who were more concerned with technological possibilities, rather than with what photographers actually wanted or needed. We were also worried about buying into a system which was here today, gone tomorrow; or where the lens mount might suddenly change; or where only autofocus lenses were available.

Best of all, the Contaxes' quality is second to none. Many of the Zeiss lenses are made in Japan,

though a few (such as the 35mm f/2.8 PC-Distagon) are still made in Germany. Regardless of where they are made, the quality of both bodies and lenses is superlative.

Having said all this, we have to acknowledge that once you are past the 'quality threshold' mentioned on page 8, the advantages of the latest and the best are not great, as compared with choice of materials and technique. In other words, if your budget is small, buy something like our old Nikons or Nikkormats, or even screw-fit Pentaxes. You will lose some versatility, and some convenience; but provided you stick with the right lenses, which are the subject of the next chapter, you will sacrifice little or nothing in the way of quality.

If you can afford it, on the other hand, the best cameras today will entail absolutely no loss of quality or versatility compared with the very best designs of the past, and will be a lot more

convenient to use. The assertion that 'they don't build 'em like they used to' is without foundation, provided you buy the right cameras. There is nothing wrong with using plastic on the outside of the camera – the Contax Aria is plastic clad – but a proper die-cast chassis (again as found in the Aria) will ensure the same sort of durability and precision as was customary in the best cameras of the past. What you don't want – though it is found in some cheap cameras – is a plastic chassis or – something which is at least as bad – a plastic lens mount.

AUTOFOCUS

In some areas, such as news photography, autofocus has swept the board. But quality never counted for much in news pictures, as evidenced by the rise of digital imaging. We are no longer so violently opposed to autofocus as once we were, but we still see no evidence of any advantage in autofocus for the vast majority of photography – indeed, for any photography where there is time to focus the lens – and we would suggest that often, autofocus delivers poorer quality than man-

MILLER
Shooting Delta 3200 in medium format gives similar grain, at a given enlargement size, as you would expect from shooting Delta 100 in 35mm. The great advantage is another 5 stops in speed, which allows you to stop down well for depth of field and to use a faster shutter speed to avoid camera shake.
ALPA 12 SWA ON TRIPOD, 35/4.5 APO-GRANDAGON ON 6X9CM. (FES)

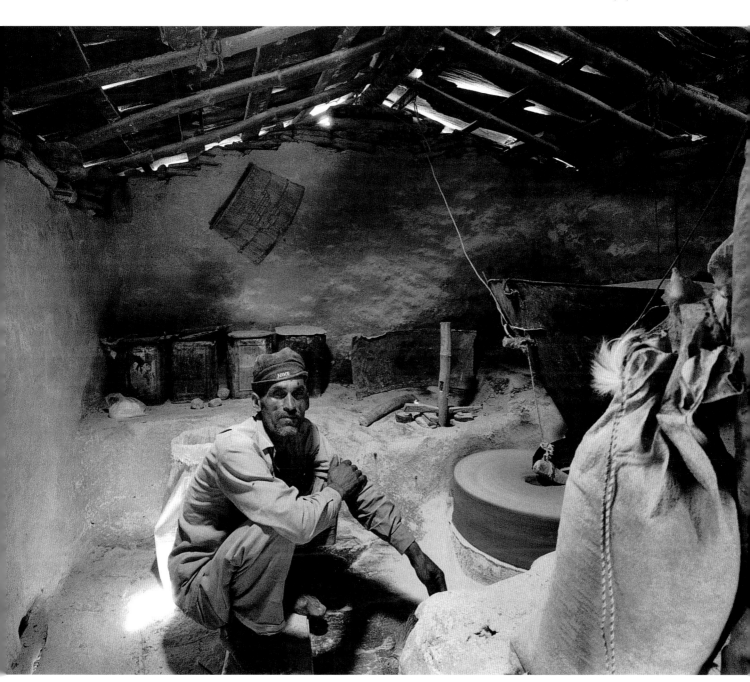

ual focus, because it discourages careful focusing and the use of depth-of-field scales.

THE COMPROMISE: ROLL FILM

To paint a caricature, roll film survives because professionals are lazy and penny-pinching. With a roll-film camera you can, with the minimum of effort, get the sort of quality which requires real energy and dedication with 35mm. You do not, however, run yourself into the kind of expense which is associated with 4x5in or still larger formats.

The numbers make it clear. Consider even the smallest 120 format, the so-called 645: 'so-called' because it is actually about 42x56mm. To make a 12x16in (30x40cm) blow-up from 645, you need an enlargement of just over 7x; an on-the-film resolution, sticking with our 8 lp/mm criterion (see page 19), of 56 lp/mm assuming a perfect enlarger lens, or maybe 60 to 65 lp/mm after allowing for losses during enlargement. This is no problem whatsoever, with a good camera and lens.

Admittedly, the half-tone effect may start to come in at as little as 8x10in(20x25cm), though by careful choice of film and developer you may be able to extend this to maybe 10x12in or larger. Alternatively, switch to a faster film – Ilford HP5 Plus is wonderful – and live with the grain at 12x16. What 645 does, as compared with 35mm, is tips the balance: quality is no longer anything like so hard to achieve.

Move up to the largest common 120 format, the so-called 6x7cm (typically 56x68mm to 56x72mm), and a 12x16in (30x40cm) enlargement is rather under 5.5x. You now need 5.5x8 = 44 lp/mm. Although it is harder to achieve high resolution over a larger area, both because of lens design constraints and because of reduced film flatness, it is still entirely feasible to achieve figures a good deal higher than 44 lp/mm. Also, although a 5.5x enlargement is around the size at which the half-tone effect may become apparent, it does not require much effort to suppress it: a slightly slower film, a fine-grain developer.

Among the other roll-film formats, the old

WAGON
Perhaps curiously, as noted in the text, we use more Delta 100 in 120 and 4x5in than we do in 35mm. Giving it a little more exposure and a little more development, in order to get the tonality we like, increases grain and reduces sharpness unacceptably in 35mm, but with the larger formats, the penalty is negligible.
ALPA 12WA, 38/4.5 BIOGON ON 44X66MM. (RWH)

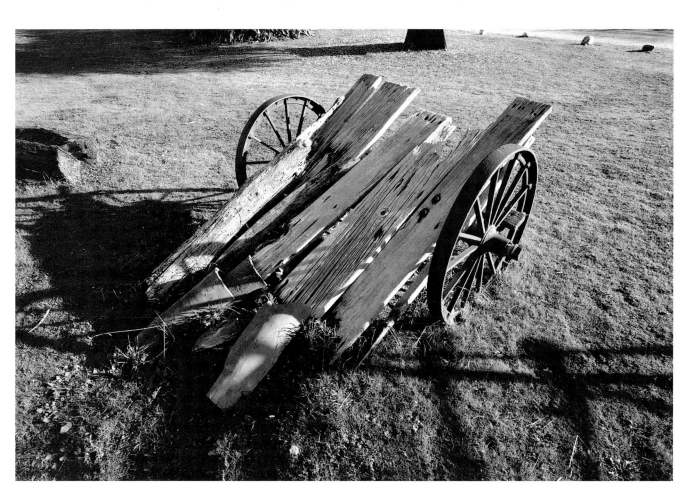

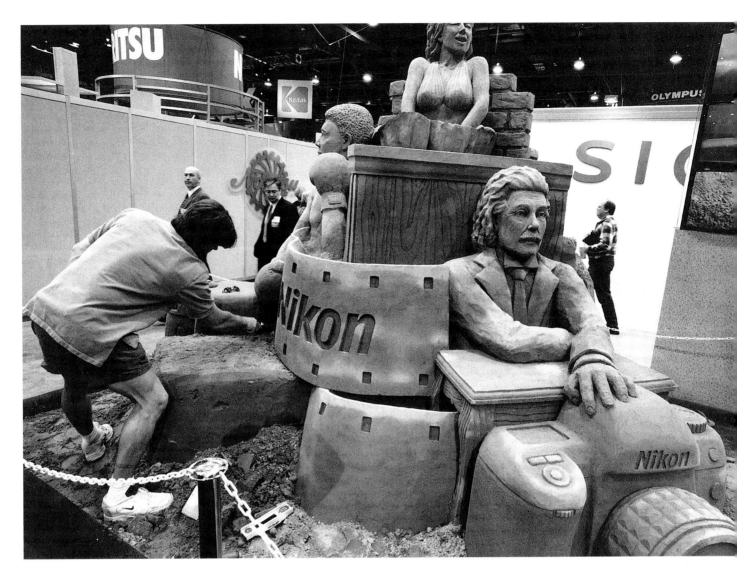

6x6cm format is effectively identical to 645 when it has been cropped to normal print sizes – though there are some people who like square prints – and the larger formats are only of use when you are dealing with relatively long, thin prints.

Fuji's 6x8cm fits very handily on to A4, requiring about a 3.7x enlargement instead of the 4x enlargement which is needed from 6x7cm, and 6x9cm requires the same enlargement on to A4 (the short dimension of the negative is the limiting factor) but crops very nicely to make a panorama across the top three-quarters (or more) of an A4 double-page spread: a 5x enlargement fills the width, and gives an image some 11in (28cm) deep, for what amounts to an 11x16.5in (28x42cm) print.

The advantages of still longer, thinner formats are disputable. They look impressive on the light table, and if your personal vision involves making

long, thin pictures they are great; but film flatness is never as good as it can be for shorter formats, and the pictures often end up being enlarged to the same extent anyway. A double-page spread in an A4 magazine is 5.3x off either 6x9cm or 6x12cm, because the short dimension (56mm) of the image is the determining factor. Reloading can become inconveniently frequent, too: 8-on (6x9cm) is not too bad, but 6-on (6x12cm) and 4-on (6x17cm) can be somewhat wearing. Although we own a 6x12cm back, we increasingly often crop 6x9cm or even 6x7cm instead.

Finally, the unique Alpa 44x66mm format, which is masked down from 6x7cm, was conceived as a way to get the best from the legendary 38mm f/4.5 Zeiss Biogon. This lens has an image circle of only 80mm, and is best known on the 6x6cm (56x56mm) Hasselblad format, which has an area of 3136sq mm, some 8 per cent larger than the

NIKON STAND
The 38/4.5 Zeiss Biogon is justly a legendary lens. On the 44x66mm format, it is almost exactly equivalent to 20mm on 35mm, and with Delta 3200 it makes a very interesting reportage lens indeed. This was at the Photo Marketing Association Convention in Las Vegas; the sculpture is entirely of sand.
ALPA 12 WA HAND-HELD.
(RWH)

COST OF CAMERAS AND FILM

New LF cameras and lenses are undeniably expensive, though they are no more expensive than new top-end 35mm equipment or professional MF cameras, and they can be a lot cheaper, especially if you start buying shift lenses – and remember that with LF, almost all lenses are shift lenses. On the used market, there are incredible bargains to be had: the price of a new, mid-range SLR outfit will buy you a complete, used 4x5in outfit, with two or three lenses.

And although film costs more per exposure than 35mm or MF, you make far fewer exposures. It is quite easy to shoot half a dozen rolls of 35mm in a day, but with large format, half a dozen shots would represent a good day's work for many people. This is a quarter of a 25-sheet box of film. Even in 8x10in, where a box of film costs the same as 15 to 20 rolls of 35mm, half a dozen sheets equates to less than five rolls of film. In 5x7in, it costs about the same as a couple of rolls, and at 4x5in, it is comparable with one roll.

EASE OF USE

When Frances first started to use LF, she said, 'These are cameras for lazy people!' It is true that there are no interlocks and no idiot-proofing, so that you have to remember to cock the shutter

CHECKLIST FOR OPERATING LARGE-FORMAT CAMERAS

1. Open shutter; set lens to maximum aperture.
2. Focus and compose, using movements as necessary.
3. Close shutter; set to working aperture; check shutter cocked.
4. Insert film-holder; remove dark-slide.
5. Take picture.
6. Replace dark-slide, black side out (to denote exposed film).
7. (optional) Open shutter and re-check picture on ground glass.

may be built down to a size and weight, because people don't want to carry anything bigger or heavier. And they may, principally for advertising purposes, be 'stretched' to a specification which they cannot support: typically, too long a zoom range, or too fast a maximum aperture. Even quite expensive zoom lenses, costing as much as a medium- to high-range SLR body, may well suffer from the third problem, and there are plenty of lenses which suffer from all three.

The consequences are all too obvious:

resolution is low, contrast is low, sharpness is low. Whenever we see a picture with one or more of these faults in a photo magazine, we check the technical data. Where it is given, we almost invariably find that the shot was made with a zoom. Even the very best zooms cannot quite compete with the best prime lenses, and anything less than the best zooms is not really worth bothering with.

Among prime lenses, there are three things to consider. The first is that newer lens designs tend, if they come from the same manufacturer, to be better than old designs. The second is that the gap between good and bad lenses was a lot wider in the past, so that a good lens from the 1970s or even the 1960s may well compare very favourably with its modern counterpart, while a poor lens of the same vintage may barely be fit to use as a paperweight. The third is that some lenses are much easier to design and build than others, so that if you stick with modest speeds and modest apertures, and eschew ultra-wides, you can find some astonishingly good lenses, astonishingly cheaply, on the second-hand market.

CHEAP QUALITY

If you want cheap, high-quality lenses for 35mm cameras, look for 'standard' lenses (around 50mm) and 'short tele' lenses (typically 85mm to 105mm). Look too for modest apertures: f/1.8 or f/2 for 'standard', f/1.8 to f/2.8 for the short teles. There are exceptions, but these lenses will generally offer very high quality at very modest prices.

In roll film, the same arguments apply, *mutatis mutandis*. Now, you are looking for lenses in the 80mm to 150mm range, typically f/2.8 and f/3.5. And with cut film, just about any coated lens made since World War II is likely to be very good for monochrome, though in colour especially, older lenses may well lack the contrast and 'sparkle' which you find with the latest and best multi-coated lenses.

The lenses to avoid, in all formats, are old wide-angles. There are exceptions, but they tend to be only from the very highest-quality makers: Zeiss Biogons from as far back as the 1950s, for example, are still astonishingly good. But even among new wide-angles, you need to avoid some of the cheaper offerings, especially for 35mm cameras.

◀ **TREES, CALIFORNIA**
*These two pictures
were taken within seconds
of one another, with
two different lenses on two
different formats. The one
Roger took with the 38/4.5
Biogon (on an Alpa WA,
44x66mm) exhibits much
less flare than the one
Frances took with the
35/4.5 Apo-Grandagon (on
Alpa SWA, 6x9cm). At least
in part, this is because the
Biogon is a simpler design:
the image circle of the Apo
Grandagon is around
50 per cent greater, with
a focal length almost
10 per cent less.*

LENSES AND MAGIC

There is no doubt about it: some lenses have a certain 'magic' which is not really quantifiable. One of the most astonishing is the 38/4.5 Zeiss Biogon on Roger's Alpa. Two more Zeiss examples are the 35m/2.8 Zeiss PC-Distagon and the 100/2.8 Makro Planar on Frances's Contax. Yet another is the 210mm f/5.6 Rodenstock Apo Sironar which we use on various 4x5in cameras. 'Magic' combines contrast, resolution, tonality and more.

Although all of these lenses seem to be 'magic' with all films, there are others which may be 'magic' in black and white, but are less so in colour. There are quite a lot more of these, and they include a number of older lenses from the 1960s and even earlier. A few examples include the 58mm f/1.4 Nikkor which we wish we had never sold; our 65mm and 120mm f/6.8 Angulons; and our 85mm f/1.9 Super-Takumar, which cost us next to nothing.

LENS COATING

Today, when all lenses are coated, there is little need for an in-depth discussion of the concept. It is, however, worth pointing out that the big difference is between uncoated lenses and plain coating; multi-coating matters mainly with exotic glasses, deep curves, or lenses with numerous

MONTREUIL-SUR-MER
The overall flatness and blue tinge of this picture is typical of what you can expect from older lenses – even first-class older lenses such as a Linhof-selected 105/3.5 Xenar on a (tripod-mounted) 'baby' Super Technika IV. You can do a certain amount with an 81C or 81EF filter and a higher-saturation film, but in colour, a newer lens such as a 100/5.6 Apo-Symmar is easier. In monochrome, older lenses present fewer problems. On the other hand, Frances, who shot this picture, maintains that it is exactly what she visualized.
KODAK VPS 6X7CM. (FES)

CALCULATING REFLECTIVITY

The formula for the light reflected from a normal ray (that is, one that is perpendicular to the glass surface) is

$$\text{Reflected light} = \frac{(1-x)^2}{(1+x)^2} \times 100 \text{ per cent}$$

where x is the ratio of the refractive indices. The refractive index of air is 1.

The perfect coating would itself have a refractive index equal to the square root of the refractive index of the glass. This is very hard to achieve, but the most usual traditional coating material, magnesium fluoride (MgF), has a refractive index of 1.39. This would work perfectly on glass with a refractive index of 1.93, which is higher than any normal optical glass, but it still provides very useful suppression of reflections with other glasses, as the following table shows:

Refractive index of glass	Reflectivity (per cent) for uncoated surface	Reflectivity for single-coated (MgF) surface
1.5	4.00	1.40
1.6	5.34	0.74
1.7	6.72	0.31
1.8	8.14	0.10

Happily, the maximum effect occurs exactly where it is needed, with glasses of high refractive index: reflectivity of a glass with a refractive index of 1.5 is reduced by about 65 per cent, but with a refractive index of 1.8, it is reduced about 99 per cent.

air-spaced elements, and it is more important in colour than in black and white.

The reflection at a glass/air surface depends on the refractive index of the glass: the higher the refractive index, the greater the reflectivity.

Coating works in two ways. The first is by providing a thin film of lower refractive index than the glass. That way, although you get two reflections (one at the air/coating interface, one at the coating/glass interface), the sum of the two is much less than the single reflection would be at a glass/air interface.

The other way it works is by being one-quarter of the thickness of the wavelength of light. This means that as the light is reflected back out, 'interference' takes place and the reflection is suppressed.

A single coating can only suppress reflections for a single wavelength. So as to suppress additional wavelengths, it is possible to stack coatings of different materials; this is 'multi-coating', the

ROAD AND TRUCK
To a considerable extent, lens sharpness is a snare and a delusion in black and white, because it encourages us to blow images up more than they can stand – the limit, as discussed on page 22, normally being set by the half-tone effect. Even so, there is no such thing as too much sharpness; when the wonderfully vintage-looking truck on the left of the overall picture is blown up, the loss of quality in itself adds to the vintage appearance.
LEICA M4-P HAND-HELD, 90/2 SUMMICRON, ILFORD XP2 ON ILFORD MG IV WARMTONE IN AGFA NEUTOL WA. (RWH)

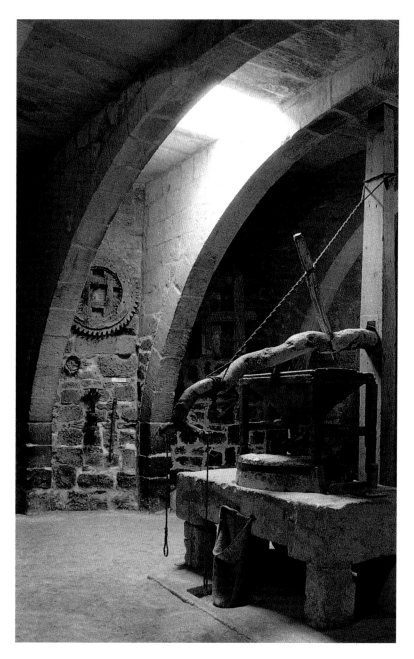

OLIVE PRESS, RABAT, GOZO

It may seem perverse to use an ultra-fast film (Ilford Delta 3200, at EI 3200) with a 35mm camera on a tripod; but given the need for considerable depth of field (with the 35/2.8 PC-Distagon well stopped down), and the very dim light, this allowed a 2-second exposure at f/11 instead of the full minute which would have been required with Delta 100, or even the 15 seconds which would have been needed with HP5 Plus.
CONTAX ARIA. (FES)

Indeed, many people (including us, as already noted) use very old uncoated lenses, especially on large format.

COATING AND FLARE

The most obvious variety of flare is the brightly coloured patches of light caused by internal reflections off the lens elements, most usually of the lens diaphragm; but more insidious, and arguably more important, is veiling flare.

This is light which bounces around between the lens elements, and inside the body of the camera. Some of it is reflected back out of the lens; some is absorbed by the baffles and blacking inside the camera and lens; and some ends up on the film, where it gives falsely high shadow densities. The 'flare factor' is the ratio of this enhanced shadow brightness to the shadow brightness which would exist in a perfect lens/camera combination (with no flare).

It cannot be assigned a single constant value, because it depends on the distribution of the light and dark areas in the original image; on the number of glass/air surfaces; on the coating; and (which is often forgotten) on the camera in use. Very roughly, an uncoated lens in a 1930s roll-film camera might have had a flare factor of 4; a 1960s single-coated standard lens in a typical SLR of the period might have had a flare factor of 2 or less; and a modern multi-coated lens in a well-blacked large-format camera can have a flare factor which closely approaches unity, that is, no flare at all.

COATING, FLARE AND COLOUR BALANCE

Because coating has a detectable colour of its own – typically straw or purple for single coating, or green for multiple coating – it inevitably affects the colour of the image. This matters very little in black and white, but with colour film, there are two things worth noting. One is that colour balance may be 'fine tuned' by choosing the appropriate colour of coating: even 'multi-coated' lenses often have some elements which are only single-coated, partly for this reason. The other is that different manufacturers' lenses may have slightly different colour balances, though this is also influenced by the glasses used. Historically,

first experiments in which date back to Germany during World War II. The first production lens to have been multi-coated seems to have been the Leitz 35mm f/1.4 Summilux in the 1950s.

With simple lens designs, the benefits of multiple coating are much less than they are with complex multi-element lenses, or with lenses incorporating elements with very deep curves. Although even a simple lens (such as the Rodenstock Geronar, an air-spaced triplet) will benefit from multi-coating, single coating is perfectly adequate, especially in black and white, and a sufficiently simple lens design can give quite adequate performance without any coating at all.

Japanese lenses have been 'warmer' (more yellow) than German, though this may be as much a consequence of glass impurities as of coating.

Regardless of the colour of the coating, the colour of veiling flare (as described above) is typically blue out of doors, because it takes its colour from the sky, and reddish (for tungsten) or greenish (for fluorescents) indoors. These colour shifts can be controlled with the appropriate filters: an 81-series out of doors, and very weak blue or magenta filters indoors, though indoor lighting is usually much less of a problem. With the appropriate filter, lenses which are flat and blue when used out of doors with colour will not only lose their blue cast; they are quite likely, in most cases, to appear to increase quite significantly in contrast.

GETTING THE BEST FROM A LENS

Regardless of the lens you use, there are several things you can do in order to get the best possible quality from it. One is to use it on a tripod, and another is to use a lens shade. There is more about these indispensable accessories in Chapter 5. There are three other things which concern us here. One is choosing the right focal length; the second is using it at the right distance; and the third is using the lens at its optimum aperture.

Choosing the right focal length may sound like an odd consideration. Surely, the right focal length is the one which covers the right field of view? Well, yes, except that you can often cover the same field of view with a longer focal length, by moving further away, or a shorter focal length, by coming closer. Unless you use a very high-quality wide-angle, it will deliver inferior quality to what you would get with a less extreme lens, and with any very long lens, there is a greater risk of image degradation as a result of vibration, atmospheric haze or even atmospheric movement. We got rid of our 1200mm lens because atmospheric shimmer was clearly visible in the viewfinder except early in the morning on cool days.

Likewise, choosing the right distance may seem odd, but it is important to remember that lenses are optimized for different focusing distances. A typical, average sort of optimization will be anything from 25 focal lengths (2m/6ft 7in for an 80mm lens) to 'infinity', which may in turn range

from 20m (60–70ft) to 100m (330ft).

Most lenses perform very well across a far wider focusing range than that for which they are optimized, but some deteriorate quite markedly, especially when they are focused very close. The 'magic' 58mm f/1.4 Nikkor mentioned above, for example, suffered from severe curvature of field when focused close, so that it was impossible to hold both the centre and the edges of an image in

ROPE WORKS, CHATHAM DOCKYARD
Extreme wide-angle lenses – this is a 14/2.8 Tamron – require care in both levelling and composition if they are to be used successfully. Once you start to use them, however, it is all too easy to become addicted to them.
CANON EOS 5 ON TRIPOD, ILFORD DELTA 3200. (FES)

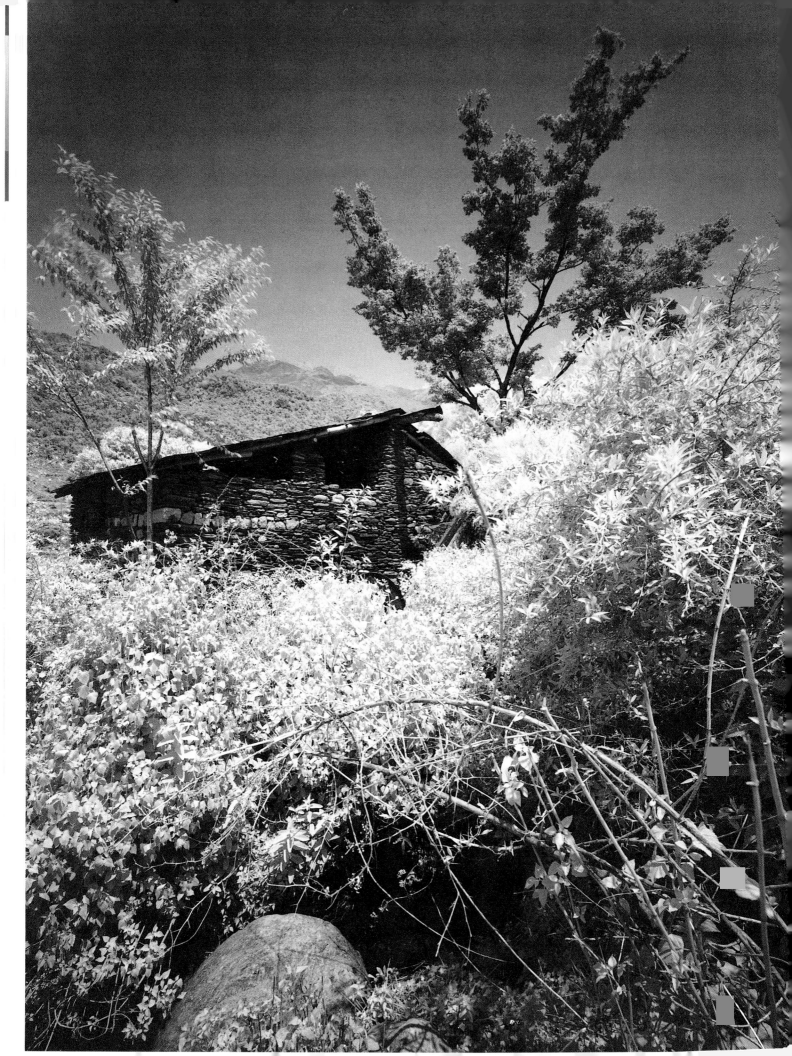

CAMERAS WITH SPOT METERING

If your camera has a spot metering option, explore it with negative films. You may even care to set a film speed which is 2 to 3 stops higher than the ISO speed; meter the shadows; and then give the recommended exposure. This is of course the same as using the ISO speed and then giving 2 or 3 stops less than the meter recommends. As we began this book, we were just coming to grips with our first camera to incorporate spot metering, the Contax RX, and we were still using our Pentax and Gossen spot meters more than the meter in the camera. By the time we had finished it, we were using the camera meter somewhat more.

When metering for colour negative film, an incident light reading will normally give a good exposure, but a spot meter reading of the shadows will be even better.

BRIGHTNESS RANGES

One reason why it is easier to use separate, hand-held spot meters, rather than in-camera spot meters, is that most spot meters make it easy to measure brightness ranges. The Pentax meter, for example, has an IRE (Institute of Radio Engineers) scale, which covers a brightness range of 100:1. If your darkest shadows with detail are at one end of the scale, $2\frac{1}{3}$ stops below the mid-point, and the brightest highlights with texture are at the other end, $2\frac{1}{3}$ stops above, then you should be able to 'hold' both on the same negative. If the brightness range is much greater, you must decide which to sacrifice – and reading a few mid-tones can help you to decide the best direction in which to bias your exposures.

FILTERS

Filters can be divided into three categories: subtle, dramatic and excessive.

Subtle filters include mild warming filters such as the 81-series, grey grads, most applications of polarizers, and (in monochrome) green or weak yellow filters for landscapes, and weak blue filters for portraits. The point with a subtle filter is that it never announces its presence. Even a skilled and observant photographer should be unable to say for certain that a filter has been used; the result should look like a happy confluence of luck and

the right circumstances – though as a famous golfer is reputed to have said, 'The more I practise, the luckier I get.'

Dramatic filters are normally used in black and white: oranges and reds, to accentuate clouds against blue skies. Polarizers can also be used dramatically, to show boats apparently floating in mid-air (on clear water with the reflections removed) or to boost colour saturation. Knowledgeable photographers will almost always spot when they have been used; non-photographers will merely know that the skies somehow seem 'more real' than in real life. This is the important thing about a dramatic filter: it builds on what is already there, but lends it unusual emphasis.

Excessive filters superimpose something on the scene which was not there to begin with. They are epitomized by the utterly loathsome 'tobacco grad', which has stained cloudy skies an unconvincing amber-brown for years.

Filters, like tripods, are a hassle; but many good photographers use (or used) filters extensively: Ansel Adams used yellow, green, orange and even red filters surprisingly often. Some people shun filters because they are not faithful to the original scene, though this argument does not withstand examination: after all, how faithful to a whole, inhabited, rumbustious, windy landscape is an image frozen in time on a square of paper, or an image flashed on a screen?

We sometimes feel that we use filters less than we should: about 10 per cent of our pictures would probably be improved if we used them more extensively. This only applies to subtle or dramatic filters, though. There are only two reasons to use what we have called 'excessive' filters: one is to add interest to a dull scene, which is something that commercial photographers have to do from time to time. The other is because you are a bad photographer.

SOFT FOCUS SCREENS

If you cannot justify the expense of a purpose-made soft focus lens, there are numerous soft focus attachments on the market. The best are almost certainly Softars, originally made by Zeiss and long available only for Hasselblad, but now available in a wide range of fittings for all cameras. A much cheaper option, the results from

MILL AND FOLIAGE
A true IR filter means that you must use either a tripod, or a camera with a separate direct-vision finder, as the IR filter is visually all but opaque. The film here is Ilford SFX, which differs from both Kodak and Konica materials in having no 'green gap' between the residual blue sensitivity and the dye sensitization into the near infra-red, so a true IR filter is essential; with the other two, just about any deep red or even orange filter will suffice for many purposes.
ALPA 12 SWA ON TRIPOD, 35/4.5 APO GRANDAGON, 6X9CM. (FES)

BURNING TREE STUMP
Anyone who is honest will admit that often, film choice is more a matter of what happens to be in the camera than of careful planning and consideration. This was Velvia, which has given wonderful colours and saturation; the negligible depth of field is as much a consequence of the image size (about one-fifth life size) as of the need to use a particularly wide aperture.
NIKKORMAT FTN HAND-HELD, 90/2.5 VIVITAR SERIES 1. (FES)

example) heavy dye release in the blue-sensitive layer(s) is accompanied by a corresponding release of dye inhibitors. These automatically limit contrast, and by diffusing through the other layers, they also inhibit the release of other dye colours, resulting in improved saturation.

The contrastiest colour film of all time was probably the old East German Orwo material, now happily long forgotten. It gave lots of colour saturation (though not necessarily very convincing colours), but at the price of horrendous contrast. Of course this could be used creatively, but for many shots, it was totally inappropriate.

For the reasons given above, modern films deliver better saturation than old ones, without the grievous contrast penalty. The first of the new generation of high-saturation slide films was Fuji Velvia, which tended to be a 'love it or hate it' film: colour was wonderfully saturated, and still lifes of fruit and the like could be really eye-popping, but contrast was still higher than many people liked, and exposure was very critical. To make life still more interesting, few found that they could get results they liked at the rated speed of ISO 50: in practical use, EIs of 40 and even 32 were quite common. Kodak's 100VS, introduced in 1999, marked the coming of age of this sort of film, still with powerful saturation – again, to be honest, more than many people liked – but with more believable contrast and surprising exposure latitude at its rated ISO 100 speed.

Colour negative films had, however, solved the problem somewhat earlier, via the adoption of a fourth, cyan-sensitive emulsion layer. Although this produced a bare minimum of dye, it produced a goodly amount of dye inhibitors, allowing still better control of contrast while retaining good saturation. All the latest colour negative films use similar technology, and the improvements are spectacular: films like Fuji's Reala series and Kodak's Portra are genuinely better in every way than their predecessors.

COLOUR BALANCE

This is almost entirely a matter of taste, though we always bear in mind a wonderful remark from the late, great Terence Donovan: 'Have you ever had a client complain because the picture is too ****ing warm?'

It is also worth bearing in mind that a

transparency film which is superb when slightly 'rich' (that is, under-exposed) may be milk-and-waterish when over-exposed, while another film may be light and airy when given a touch of extra exposure but dark and muddy with the same amount of under-exposure. As a (very) general rule, fast films tolerate over-exposure better, and slow films tolerate under-exposure better.

Colour balance is principally a matter of concern with slide films, as an immense amount can be done with negative films at the printing

LEAVES
One of the hardest things for any photographer to get used to is the discontinuation of a favourite film. This would win no prizes for sharpness, but the colours are wonderful. It was one of the last rolls of Fuji's ISO 50 RF/RFP, which was probably Roger's favourite colour film of all time.
NIKKORMAT FTN HAND-HELD, 90/2.5 VIVITAR SERIES I MACRO. (FES)

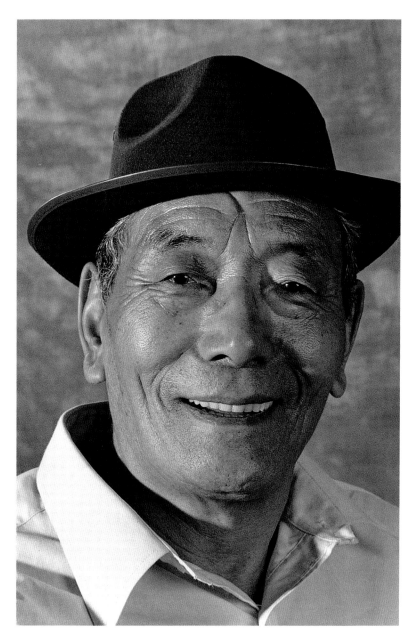

RESISTANCE FIGHTER
The Tibetan administration in exile wanted portraits of some noted people – this man was second-in-command in the Chushi Gangdrug resistance movement – and we had to work with what we had at hand. Although we would have preferred medium or large format, the famously sharp 90/2 Summicron on the Leica M4-P teamed up well with Ilford XP2 to give more than adequate results for a 'mug shot'.
CAMERA HAND-HELD PRINT ON MG WARMTONE, SELENIUM TONED. (RWH)

TONALITY IS A MATTER OF PERSONAL PREFERENCE

The examples given above, where a 'faster' film ends up with an ISO speed within ⅓ stop of a 'slower' film, might seem always to argue for the slower film; but you might (or might not) prefer the tonality which you get with the faster film in the ultra-fine-grain developer. You might also find that you preferred the tonality of either film in a 'normal' developer such as Kodak D-76/Ilford ID-11.

A perennial truth with black and white photography is that the only way to see if something works – or if you like it – is to try it.

IN MONOCHROME, BOTH OLD AND NEW FILMS HAVE ADVANTAGES

As already intimated, many photographers refuse to have anything to do with monosize crystal films: they put up with the inferior speed/grain ratio of cubic crystal in return for what they see as superior tonality. Also, as noted above, cubic crystal films are more tolerant of abuse than monosize crystal.

Paradoxically, we like Ilford 100 Delta much better in 120 and 4x5in than we do in 35mm, where the improved speed/grain ratio might seem to be much more important; and in 35mm, we shoot a great deal of 'old technology' Paterson Acupan 200, because we love the tonality.

**KOREAN-AMERICAN
FRIENDSHIP BELL**
*This was one of the first
shots Frances took on
Kodak Portra 400 VC,
shortly after it came out;
it is now, without question,
her favourite colour
negative film. It is
impossible to try every-
thing new, but when
something comes out
which looks as if it might
suit your style of
photography, you owe it to
yourself to 'waste' a roll.*
ALPA 12 SWA ON TRIPOD,
35/4.5 APO-GRANDAGON
WITH SOME RISE, ON 6X9CM.

IN COLOUR, NEW FILMS GENERALLY HAVE THE ADVANTAGE

Although there are some wonderful old films such as Kodachrome 25, it is generally true that the newer a film is, the better its speed/grain ratio will be, and the more attractive the colours. This is, of course, assuming that you actually like the colours. Some people love highly saturated films; others hate them. Some greatly prefer a warm colour balance; others prefer something more neutral, though warmth is becoming more and more the norm. *De gustibus non disputandum est*, and newer films generally cost more money; but if you try them, you will often find that they are worth it.

SHOULD YOU CHANGE FILMS?

The choice of films is so wide that it would be entirely possible to spend all one's time shooting new and improved emulsions. This is especially true if you do not shoot much film – if you are the kind of photographer who rarely finishes one film in a day, let alone two or three. In fact, if you shoot fewer than a dozen or two dozen films a year, it is quite possible that the manufacturers will start gaining on you: new films will come out faster than you can try them.

There are, therefore, two possible approaches. One is that you stick with what you know, and eschew anything new. The other is endless

**VERANDAH OF
TARAGARH PALACE**
*Mark Szejbach, a long-
time user of Ilford HP5
Plus, said that he loved
the way it gave him
tonality 'like Casablanca'
(the film, not the place).
Despite the half-tone
effect, 35mm HP5 Plus
does indeed have a
unique and magical
tonality, though the effect
is often somewhat differ-
ent from the medium-
format film.*
CONTAX ARIA ON TRIPOD,
100/2.8 MAKRO-PLANAR. (FES)

experiment. Each has its advantages. With the former, you can concentrate on making pictures; with the latter, you will have the benefit of the latest and best technology.

Neither extreme is ideal. We used to follow the first path. Then, by chance, we tried Ilford XP1 (as it was in those days). We suddenly realized that we had been missing out on a film with ISO 400 speed, and the grain of an ISO 100 film; so it joined our palette of films. Ever since, we have tried to keep the range of films which we use to a minimum, while trying at least the more

interesting-sounding films as they come out. Of course, the fact that we write for the photographic press means that we sometimes have to try more films than we really want to.

TOO MANY FILMS

It may sound odd to say that we have to try more films than we really want to, but the logic behind it is simple. Any picture has both an aesthetic and a technical dimension. With an unfamiliar film, there is always the danger of getting it wrong, technically: of wrong exposures or wrong develop-ment. There is also the danger that you simply will not like the film. If you have, in the meanwhile, used this new film to shoot a picture which you know would have been great on your old film, it can be mightily depressing.

The standard advice, of course, is that you should never shoot anything important on a new film. But how do you define 'important'? Whatever film we are using, unless we are looking for straight sensitometric and similar data, we like to try to make attractive pictures of the sort of subjects which we normally shoot. If we did not, after all, we could hardly make a meaningful comparison of the old and the new films.

What we do, therefore, is to go to the sort of place where we would normally expect to get good pictures, and then shoot at least two rolls of film: one of the old, and one of the new. We then accept that the new film may be disappointing (or, of course, that we may get it wrong).

This is, as far as we are concerned, the only way to test a new film: to blow a whole roll, straight off, alongside another film whose characteristics we know. A common reaction to this is, 'It's all right for you, but film is expensive.' Well, yes and no. A roll of film may not be a completely trivial purchase. But equally, it is not a fortune either. And if you want to learn what a film can do for you, there is no other way to do it meaningfully.

TOO FEW FILMS

The mirror image of endless experiment is sticking with a single film, or with a very limited range of films, for all your photography.

There are two disadvantages to this approach. One is that you will miss out on genuine technical advances, and the other is that you will become

ever more inward-looking, ever more preoccupied with your own pet theories or with those of some guru, with the result that the technical standard of your pictures actually deteriorates.

In large-format black and white, especially if you only ever make contact prints, you can pretty much get away with sticking with any one film. Sharpness and grain are hardly relevant, and you could get perfectly good results with the films of the 1950s or even the 1930s (though you might find the latter a little slow).

In medium-format monochrome, too, advances in sharpness and grain are far less important than they are in 35mm, and tonality is your main concern.

Move down to 35mm, and in our opinion you would be extremely foolish not to try new mono-chrome films from time to time. This is where magazine reviews come in handy. Oh, everyone knows that these tests are not always very objective; that all too many magazine articles are written by journalists, not photographers; that even the photographers may have a shaky grasp on how to test a film meaningfully; and that some magazines (not all) are unduly beholden to their advertisers and will not, therefore, even begin to hint that any new product is less than perfect. Even so, it is possible to read between the lines, and to form an opinion of whether a new film might, or might not, suit you.

In colour, our view is that you should always keep an eye on new films, regardless of format. At least once a year, a really good new film comes out. The most recent, as we wrote this, were Fuji Astia, and a whole slew from Kodak: the Portra negative series, the E200 Ektachrome which could be pushed to EI 1000, and Ektachrome 100VS high-saturation film. By the time you read this, there will be more.

OLD FAVOURITES

Trying new films most emphatically does not mean that there is no room for old favourites. In large format, we still use a great deal of Ilford FP4 Plus and Ilford Ortho Plus (the successor to Ilford Commercial Ortho), alongside Delta 100 and a constantly changing array of colour transparency films. In medium format, alongside Ilford Delta 100 again, Ilford's XP2 Super (which should really have been called XP3) replaced the old XP2 easily,

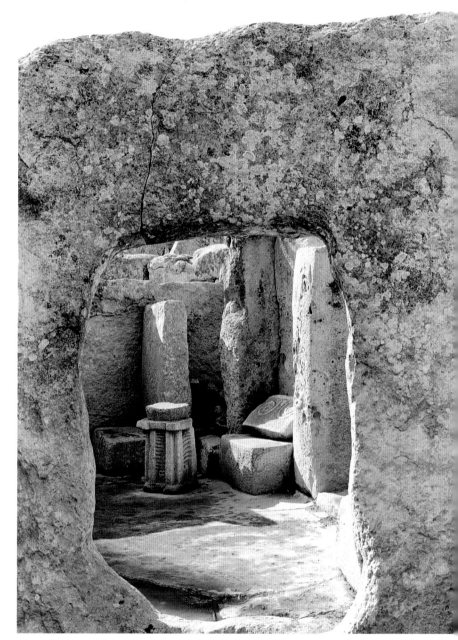

because it is an even better film which effectively offers more of the same. In this book, too, you will find a good deal of HP5 Plus, a film to which we had returned after many years' absence: we were given some to test a camera with, and found that the Plus version was much better than the pre-Plus version. In 35mm, along with the Ilford Delta 100 and XP2 Super, and Kodak's latest Ektachromes, we still have a weakness for dear old Kodachrome 25, the tonality and colour of which remains profoundly attractive to this day – even though Kodachrome long ago lost the easy lead which it once enjoyed in grain and sharpness.

HAGAR QIM
The vintage tonality here is the result of using a vintage-style ortho film, Maco Ort 25. We find that in order to get the tonality we like, without using special developers, we have to rate it at EI 6. Ortho films are of course insensitive to reds, and of limited sensitivity to the yellow of the sandstone from which this 5000-year-old temple is built. LINHOF 'BABY' SUPER TECHNIKA IV ON TRIPOD, 105/5.6 APO-SYMMAR ON 6X7CM. (RWH)

mentioned above, but here we are concerned with two other aspects. One is the degree of organization that is required to make sure you have all the equipment and materials that you need, and the other is how you spend your money in order to get good pictures.

The former is most easily solved with checklists. We have found these particularly valuable when we are tired and packing our kit late at night for a trip the next day, or when we are in a tearing hurry because we have decided to go somewhere at short notice. We have also seen the same sort of problem among our friends, when the rest of the party is ready to go, and the photographer is still agonizing over equipment.

Our checklists live on the computer, where they can be printed out in multiple copies and where (equally importantly) they can be updated to reflect changes in our equipment. To help you create your first checklist, don't rely only on memory. Make a 'dry run' as if you had just arrived at your location and were about to take a picture. This is the time to find that you need a ¼–⅜in tripod adapter, or a camera strap for the second body – not when you arrive for real!

SPENDING MONEY TO GET PICTURES

It is remarkable, as noted elsewhere, how photographers will spend a fortune on cameras and lenses, and then try to economize on film. No less remarkable is the way in which they will begrudge other ways of spending money in order to get pictures; and we do not exclude ourselves.

For instance, we find it difficult to bring ourselves to spend a bit extra on a hotel room

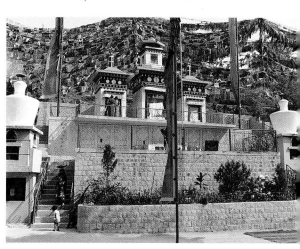

CENTRE OF ATTENTION
In one of these pictures, the eye goes first to the woman on the stairs, with the basket on her head; then to the child below her; then to the figures in front of the door. In the other, the figures are all in the wrong places and are a mere distraction.
CONTAX ARIA HAND-HELD, 100/2.8 MAKRO PLANAR, ILFORD XP2 SUPER. (FES)

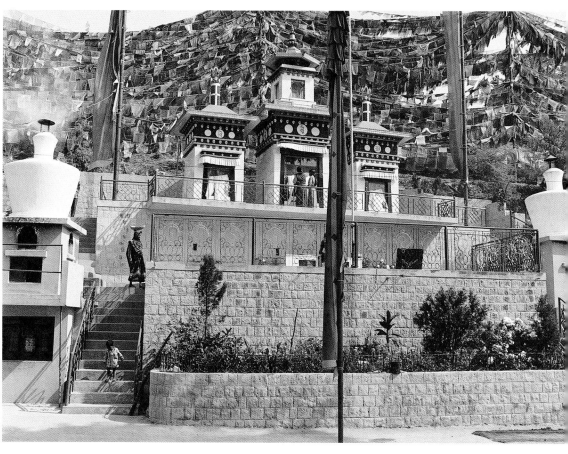

BARLEY FIELD
Without the vivid colours of the salwar-kameez *outfits, this would be a very dull picture; but we could hardly have had better colours if we had hired models. Because Indian roads seem always to be busy, we had to wait only a few minutes until someone came along.*
ALPA 12 WA HAND-HELD, 38/4.5 BIOGON ON 44X66MM, FUJI ASTIA. (RWH)

and then uncover it again. A butterfly lights.

'The decisive moment,' in Cartier-Bresson's famous phrase, is when everything comes together in the viewfinder. Often, you know that you want someone just *here*, or the sun to come out and illuminate *that*, or a particularly ugly tourist who has been loitering, seemingly forever, to go away. At the risk of sounding pretentious, the decisive moment is the temporal extension of physical composition: everything is correct in both space and time.

GOING BACK

You cannot cross the same river twice, or so it is said; the reason being that when you go back, it is not quite the same as it was. Sometimes, this can be lamentably literal. There used to be a beautiful stamped-earth towpath alongside a particular part of the Kennet and Avon Canal. Then someone surfaced it with cement, completely destroying the picturesque prospect under at least one bridge which fortunately we had photographed before the vandalism.

On the other hand, there are many places which well repay repeat visits. When we lived in California, we used to go quite often to the Mision de la Purisima Concepcion in Lompoc, and we could as happily return to the Mision San Antonio.

In Kent, we have an annual pass to Chatham Dockyard, now decommissioned and turned into a combination of a museum and an enterprise park. In France, we return repeatedly to Montreuil, and we want to get back to the Luberon, with its wonderful walled villages and narrow crooked streets. There are many other places: Birgu in Malta, pretty much the whole of Gozo, or Mertola and Trás-os-Montes in Portugal. Sometimes the changes we see are for the good, sometimes they are for the bad – but always, there is something to photograph in a new way, or in the same way but better.

SHARPNESS

To pose an unappetizing choice, the quest for sharpness often comes down to a fight between depth of field, and camera shake. On a bad day, you can add subject movement: even if the camera is on a tripod, wind can stir flowers, or people can wander in and out of shot.

This is why a fast film will, in many cases, give you better quality than a slow one. If you are hand-holding the camera, it allows a faster shutter speed, or a smaller aperture, or both. If the camera is on a tripod, it freezes subject movement, gives you more manageable exposure times, or (at the very least) makes it easier

for you to choose your decisive moment.

We sometimes use Ilford Delta 3200, even with the camera on a tripod, for precisely these reasons. In very low light levels, where with an ISO 100 film you might need 10 seconds at f/11 (the latter dictated by the need for depth of field), Delta 3200 at 3200 allows you to use ¼ second at the same aperture. In a museum, for example, a lot can go wrong in 10 seconds, from someone wandering into shot to someone kicking your tripod leg, to say nothing of the embarrassment of people who wait politely for what they think will be a moment, and then find you requesting them to hold off for several seconds more.

To be sure, we use slower films if we can – but even then, the trade-offs may be unacceptable. On a bright, sunny day in Zuerich, for example, we chose to use Ilford HP5 Plus at its rated ISO 400 speed, partly because we were hand-holding the cameras, and partly because we wanted to 'freeze' the birds that swoop and squabble over the river, and we needed ⅟₅₀₀ second (the fastest on the leaf shutters of our Alpas) to do so. This allowed us to shoot at f/11 and f/8; with ISO 100 film, we should have been limited to f/5.6 and f/4 at the same speeds, and even with the ultra-wide lenses we were using, this would not have allowed adequate depth of field.

CUMULATIVE EXPOSURES

A trick which is of limited interest, but useful if you can do it, is making cumulative exposures. A 'press' (self-cocking) shutter on a large-format or medium-format camera may be fired repeatedly, effectively without vibration, and without having to touch the camera. So may some (though far from all) cameras with a 'multiple exposure' facility.

This is especially useful if you are photographing, for example, the interior of a church, where you need a 10-second exposure but people keep wandering in and out of shot. Chop the exposure into ten, 1-second segments, and you can shoot while the church is 'empty'. Another application is photographing a landscape on a windy day. Foliage normally goes back very close

DORMITORY
This is from the same series as the other shot of the dormitory on pages 84–5; the girls are moving for the same reason. The visualization was however imperfect: there should have been girls on the nearest beds, which are all too empty otherwise.
ALPA 12 SWA ON TRIPOD, 35/4.5 APO-GRANDAGON ON 6X9CM, ILFORD XP2 SUPER. (RWH)

TEMPLE, NORBULINGKA
Rather than colour,
Frances decided to use
monochrome, toned (in
sulphide) to create a
golden-bronze appearance
in the principal Buddha-
image. In polished metal,
grain is all too clear: she
chose to use 6x9cm on a
tripod-mounted Alpa 12
SWA with a 35/4.5
Apo-Grandagon, which
allowed the use of a
reasonably fast film. The
alternative would have
been 35mm with an ultra-
slow film and a fine-grain
developer.

sites to allow physical development. It is, however, a mere curiosity. We have never tried it, and we have only met one person who has (a Kodak researcher); but it is mentioned here purely out of interest.

HIGH-ENERGY DEVELOPERS

High-energy developers give coarser grain than D-76, but also higher true film speeds. True speed gains of ½ stop are quite common; ⅔ stop is not unusual; and gains of as much as a whole stop are not unknown. Any greater speed gain than this is,

however, normally at the expense of shadow detail, or involves a contrasty negative (which can nevertheless be tamed to some extent with a softer grade of paper). In other words, 'push' speeds may be usable for many purposes, but they are not true ISO film speeds.

Because this sort of 'pushing' works by increasing the overall contrast, that is, by increasing the slope of the characteristic curve, any gains will always be more apparent in the mid-tones and highlights than in the shadows, so the tonality of the final image will not be the same as for a film which has not been pushed.

The usual way to get more energy is to use more energetic developing agents, in a more alkaline solution. High-energy developers are not necessarily the same as high-contrast developers: it is possible to get high contrast, without high speed, by using a highly alkaline developer either with hydroquinone alone or with a much higher ratio of hydroquinone to metol than is normal, both developing agents being at a fairly high concentration. Most of these developers are quite strongly restrained: up to 6g/litre of bromide in M-Q developers, and as much as 20g/litre in plain hydroquinone developers.

STAINING DEVELOPERS

These are extremely interesting, in that they stain the film in direct proportion to the silver image: for obvious reasons, they are of limited interest for paper development. They give, to some extent, 'something for nothing' in the form of finer grain with excellent tonality.

Most staining developers are based on 'pyro' (pyrogallic acid or pyrogallol). This is fairly toxic and does not keep well in alkaline solutions, so pyro developers are normally made up in two-solution form, one containing everything except the alkali, and the other a straightforward sodium carbonate solution.

In the late 1990s, a formula known as PMK (Pyro-Metol-'Kodalk' – Kodalk is sodium metaborate) was very popular, and if you are prepared to put up with the toxicity, you can indeed get beautiful negatives; or more accurately, negatives which produce beautiful prints, though the negatives themselves look thin and strange.

POSITIVE DEVELOPERS

The big difference between films and papers is that papers are normally developed to finality: in other words, all the silver that can be developed, is developed. Films, on the other hand, are normally developed to a given contrast which is well short of finality. Lantern slides used to be processed in much the same way as papers, which is why this section is headed 'positive' developers instead of 'paper' developers.

The basic chemistry is much the same, except in two respects. One is that in order to speed development, the developers are normally more strongly alkaline, and the other is that because fog is even less welcome than it is in a negative developer, restrainers are widely used; the slight speed losses are irrelevant with paper. On the other hand, bromide must be kept to a minimum in order to get really deep blacks, so organic restrainers such as benzotriazole are popular, though higher bromide concentrations do allow warmer tones.

There are some so-called 'universal' developers which can be used at one dilution for paper, and another for film, but it should by now be clear why they are usually an undesirable compromise: they are unlikely to be active enough to give the best possible paper image, and they are likely to give quite large grain and poor speed with film. The only reason for using them is when convenience and economy take precedence over quality.

WHEELBARROW
The attraction of this picture was the silver-bright interior of the wheelbarrow against the many other textures in the scene. Unfortunately, Roger over-developed the film (Ilford Delta 100) grievously; in order to get a reasonable print, Frances had to expose MG Warmtone at grade 0 and develop it in Centrobrom. HAND-HELD ALPA 12 SWA WITH 44X66MM BACK, 38/4.5 BIOGON.

**MAN WITH PACK
ANIMALS**
*The two test strips are on
Bergger NB grade 3,
exposed for identical times
and developed in Tetenal
Centrabrom, which despite
its name is a low-contrast
developer, and Tetenal
Dokulith, which despite its
name is merely a
contrasty developer, not a
true lith developer. It is
clear that the Centrabrom
version is slightly faster
than the other, with more
overall density: even in
reproduction, the
differences in contrast
should be perceptible. The
final print was obtained by
developing the same
paper for 45 seconds in
Centrabrom and the
remainder of the
3-minute development
time in Dokulith, then
toning in sepia. Although
the camera was on a
tripod, this was a 'grab
shot', spotted and shot in
a few seconds while
Frances was setting up
another shot.*
CONTAX RX, 100/2.8 MAKRO-
PLANAR, ILFORD XP2 SUPER.

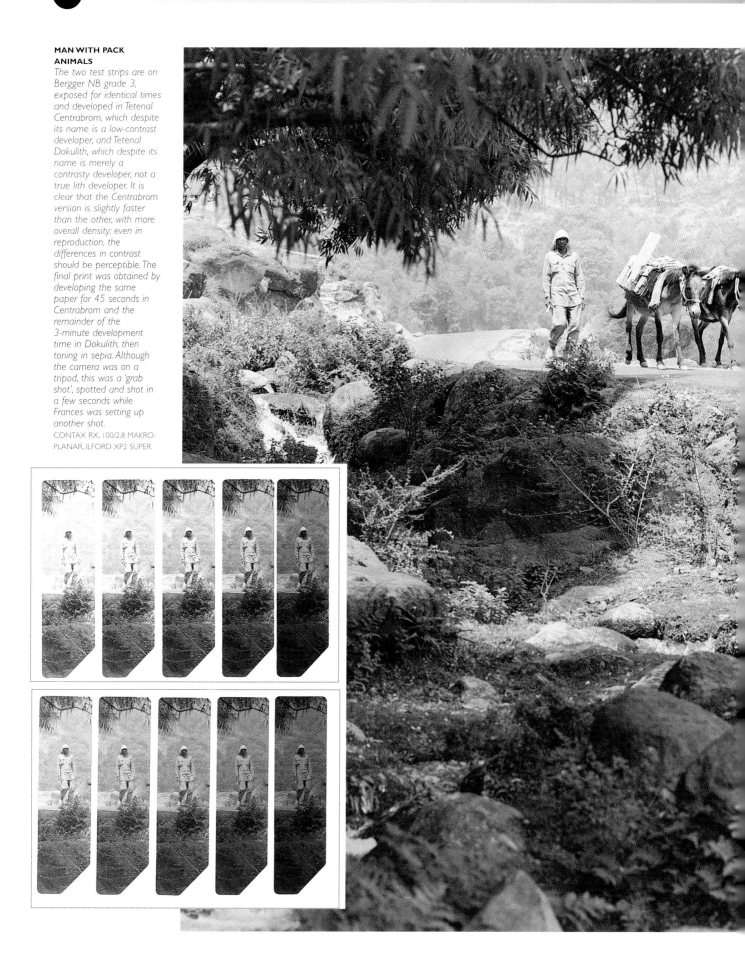

WARM-TONE DEVELOPERS

Image colour is largely a result of the size of the silver grains in the image: the smaller the grain, the warmer the tone. This in turn depends partly on the paper formulation and partly on the developer. The main difference between warm-tone and standard developers is normally that the warm-tone developers contain little or no metol (which gives blue-black tones), but instead use warm-tone developing agents, typically glycin or chlorquinol, though hydro-quinone is also widely used. It is often possible to get warmer tones with an ordinary (non-warm-tone) developer, simply by using it at higher dilutions; but development times go up consider-ably, and the density of a maximum black is likely to decrease: we have found maximum densities of 1.8 to 2.0 instead of 2.0 to 2.2.

DEVELOPER LIFE AND CAPACITY

Exhaustion of developers is only very rarely the result of the actual developing agents being used up; as described on page 109, the amount of developer which is needed to develop a film or a sheet of paper is tiny. Rather, exhaustion is the result of oxidation of the developing agents, and of the build-up of both bromide from the emulsion (which acts as a restrainer) and developer by-products which may cause staining or loss of activity because they reduce alkalinity. With paper developers, there is no great problem in using the developer until it goes off – you can always remake a print or two – but this is not a desirable approach with film.

Where throughput is considerable, a replenished system arguably offers the greatest consistency, convenience and economy, albeit with reduced film speed (see page 123); but for small batch processing, or where speed is important, one-shot film developers are the best way to go.

VARIABLE-CONTRAST DEVELOPMENT

By varying the formulation of the paper developer, it is possible to effect a modest change in the contrast of the print, even with fixed-grade papers. You can gain maybe half a paper grade in contrast, or wipe off around a whole grade.

Although it is possible to formulate developers which can be mixed in varying proportions in order to give the required degree of contrast, a much more versatile approach is to use a two-

SWAMP, NEAR SELMA, ALABAMA
Agfa's Scala is a film which fascinates us. We have seen many excellent pictures shot on it – and yet we seem to be curiously out of sympathy with it, when it comes to actually getting good results ourselves. It is a clear illustration of the old saying that one man's meat is another man's poison.
NIKKORMAT FTN ON TRIPOD. 90/2.5 VIVITAR SERIES I MACRO. (FES)

COSTUME SHOP, TIPA
Medium-format colour negative allows remarkable quality, even with ISO 400 film: this is Kodak's excellent 400VC, exposed in a tripod-mounted Alpa 12 SWA with a 6x9cm back, using a 35/3.5 Apo-Grandagon. The extra speed of the ISO 400 film more than compensates for the slower lenses and reduced depth of field (necessitating smaller apertures) of MF as compared with 35mm. The pale picture shows what happens when the processing chemistry (Paterson Professional, used with Tetenal paper) suddenly 'dies': the previous print was entirely satisfactory.
(FES)

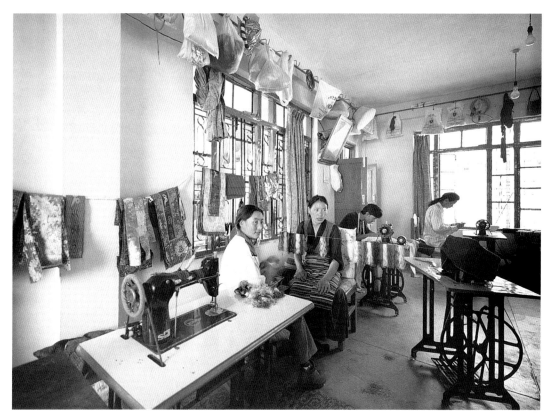

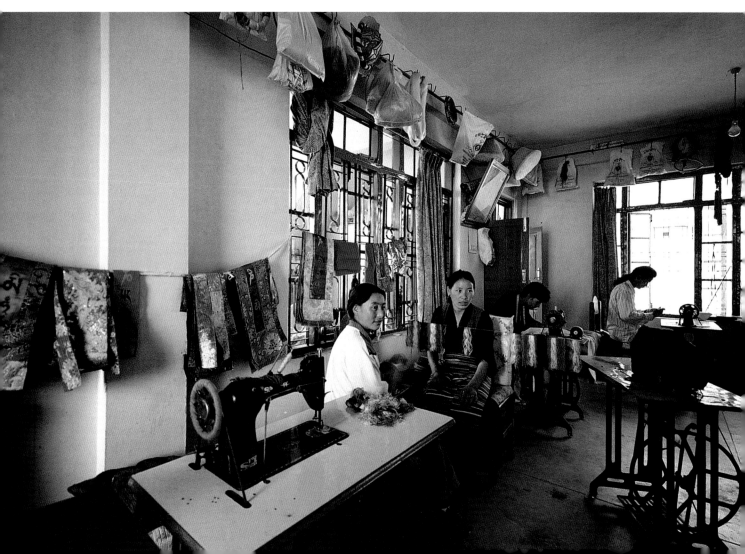

bath developer so that the paper can be given more time in one bath or the other. The big problems here are maintaining a constant image colour – which may not matter so much if the prints are to be toned – and cross-contamination, which inevitably leads to increasingly unpredictable behaviour, and also less differentiation between the baths.

For years, the only way to make up a variable-contrast, two-bath paper developer was to do it yourself, but now there are several on the market, including Tetenal's Centrabrom/Doculith. VC developers are less convenient than VC papers, but the effects are different enough to warrant investigation: VC developers affect mainly shoulder contrast, leaving toe contrast unchanged, while changing paper grade affects toe contrast.

TANNING DEVELOPERS

Tanning developers literally tan or harden the gelatine in direct proportion to the silver image, and were historically used in dye transfer and dye imbibition processes, among others. In the main surviving process which requires tanning, namely bromoil, the print is normally developed in a conventional print developer and then tanned by subsequent treatment.

REVERSAL DEVELOPERS

Conventional reversal processing involves, in effect, two developments in a row. The first processes the original (negative) image, leaving undeveloped silver halide in inverse proportion to the density of the negative. The original image is bleached out, leaving only unexposed halide, which is exposed to light, or treated chemically, to render it developable.

A second developer bath converts all (or almost all) of the remaining halide to the final, reversed image, though it is usual to give a final fix to dispose of any recalcitrant silver halide which may not have developed. Because the second development is to completion, it is rather less critical than the first, having far less effect on density.

There are relatively few monochrome reversal development kits on the market, though it is not difficult to make up a good, working process using formulae from old books. There are, however,

three significant drawbacks to reversal processing of most ordinary films.

The first, which applies to all formats, is that it is very time-consuming: the full sequence, with all necessary washes, normally takes about three-quarters of an hour, plus drying time.

The second is that maximum densities are rarely very impressive. Compared with slides made the traditional way, by printing from a negative on to positive film (or a lantern slide), the overall density range is likely to prove lean: as little as 100:1 (log range 2.0), as compared with up to 1000:1 (log range 3.0) for the printed slide.

The third applies principally to 35mm films, which are normally coated on a neutral grey base: this makes for a dull, flat-seeming transparency. If you pump enough light through it, and if it is not compared with purpose-made transparency films (such as colour slides or Agfa Scala, which are on a clear base), then this is no great drawback; but it is still visually unappetizing, for want of a better phrase.

COLOUR DEVELOPERS

The basic principles of colour development have already been covered on page 73: the incorporation of dye precursors into the film, which, during development, turn into the dye image. The developing agents which are needed to effect this transformation are different from those used for monochrome, and considerably more expensive.

For colour negative processes, the silver image and the unexposed halide are then dissolved out leaving only the dye image. For colour reversal processes, the first developer is, in effect, a slightly modified black and white negative developer and the second is the colour developer, working in the same way as a colour negative developer. Just as with conventional black and white materials, extra time in the first developer 'pushes' the film to higher usable speeds. Again, as with monochrome negative film, grain is made coarser by pushing, and after a certain point (which varies from film to film) the maximum black weakens rapidly and other colours are degraded.

Although it is possible for the 'gentleman amateur' to devise substitute formulae, the scope for disaster with colour is far wider than it is with monochrome, where almost any user error can

KHATAGS

These khatags or 'robes of the gods' are like flimsy scarves; Tibetans give them between friends on partings and arrivals, and as tokens of respect. These are laid upon a choerten *built in memory of a Tibetan martyr, who immolated himself as a protest against Chinese behaviour in Tibet. With slide film, you would need to cut exposure slightly to hold detail in the white; with negative film, under-exposure might have led to loss of detail in the black tiles, so it is best to make any necessary adjustment at the printing stage.*
ALPA 12SWA, 35/4.5 APO-GRANDAGON ON 6X9CM XP-2 SUPER. (FES)

generally be redeemed at the printing stage, so there is little incentive even to try.

As far as we have been able to find out, the main advantages of the full six-bath E-6 process over the so-called 'three-bath' version (actually four-bath, unless the stabilizer is omitted, which would be very foolish – see page 130) are that six-bath is easier to replenish and cheaper to run on a commercial scale; there seem to be no compelling quality or archival advantages in the extra baths.

CROSS PROCESSING

It is perfectly possible to process slide films in chemistry intended for negatives, and negative film in chemistry intended for slides. The former

is, however, a much more attractive option: the absence of an orange mask in a slide film is easily compensated for by adding filtration (in the form of a piece of unexposed, processed negative film, if need be), whereas the orange mask in the negative film somewhat detracts from its usefulness as a transparency.

In our view, although cross processing is a legitimate technique – pretty much anything is, in photography – it is also a technique which is grievously over-used. The distorted and generally highly saturated colours which it gives, together with more or less bizarre edge effects, may have an increasingly slight novelty value, but very few proponents of the process seem to have the artistic vision that is required to make anything worthwhile out of it.

CROSS PROCESSING
*Cross processing intro-
duces colour shifts which
are often unpredictable
and almost always
unrealistic. Combine it
with infra-red film and
the possibilities are even
greater. Our own view is
that normally, the shock
value of cross processing
is considerably greater
than any aesthetic gain.*
NIKON F ON TRIPOD, 35/2.8
PC-NIKKOR, KODAK E6 IR
PROCESSED IN C41. (RWH)

FILM PROCESSING

The previous chapter was heavily theoretical; this one is much more practical, and begins with the simple question of whether you will get better quality by doing your own film processing, or by leaving it to a commercial lab.

The answer depends on what sort of film you use, and what sort of lab. There are effectively four types of film, and for the sake of convenience, labs can be divided into amateur and professional, though it would be more realistic to think of them as a spectrum running from the finest professional labs to the worst amateur labs; in between, there will be amateur labs which work to professional standards, and allegedly professional labs to which no sane amateur would entrust his work.

THE FOUR TYPES OF FILM

Some films can only be processed in professional labs, either because of the complexity of the process (Kodachrome is the best known example) or because details of the process have not been released (as with Agfa Scala). Although both 'professional' and 'amateur' Kodachrome processing are offered, the only difference between them is that the former is faster.

Other colour slide films use a standardized process, generally known by its Kodak name of E-6, though other manufacturers have their own names. The process is mechanical, dull and time-consuming, and requires very accurate temperature control, the latter arguably at the limits of what most people can achieve. It is impossible for the small-scale home processor to get better results than a good lab; the best he can hope for are results which are as good. Unless there are compelling arguments to the contrary, it is generally best to leave it to the labs. The arguments to the contrary, and the best way of processing your own E-6, are given later in the chapter.

Colour negative films again use a standardized

KODACHROME
To this day, Kodachrome 25 is one of Roger's favourite films. The very low speed is something of an embarrassment, but you put up with it in return for the unique tonality and colour. Familiarity also means that Roger can guess the exposure for difficult grab shots like this one. Rather more of an embarrassment is having to wait several days to get the film processed.
HAND-HELD LEICA M4P, 35/1.4 SUMMILUX.

process, and again are generally known by a Kodak name, C-41. Although it is somewhat quicker and less demanding than E-6, it is still very demanding and the home processor can at best hope to equal the results of the commercial lab, so the same arguments apply as to colour

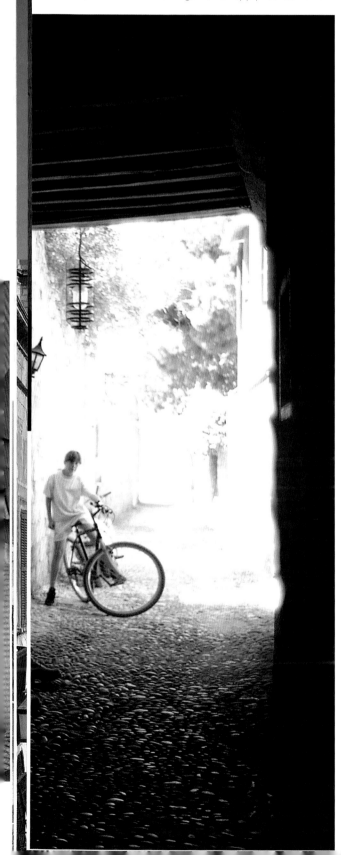

slide. Chromogenic monochrome films such as Ilford's XP-2 and Kodak's T400CN are processed in C-41, and there is little point in processing them at home, either. Again, the question of processing your own C-41 is discussed later.

With conventional (non-chromogenic) monochrome negative films, the rules are changed utterly. There are a very few top professional labs which may give results which are as good as any reasonably careful amateur can get at home; the rest will, without question, give inferior results.

There are two reasons for this apparent anomaly. One is that unlike E-6 and C-41, there is no standardized monochrome process, and different films respond best to different developers and development times. The other is that most commercial labs use 'seasoned' or replenished developers, so that there is a slight (but noticeable) loss of film speed. Some labs trust their customers to over-expose to compensate, while others take matters into their own hands, and over-develop to compensate.

Where the home processor can experiment in order to find the best possible combination of film, developer and development time, the commercial lab frequently operates, at least to some extent, a policy of 'one size fits all'. The best labs do offer a choice of developers and development times, but the worst simply put all films through the same developer for the same time – generally a long time, so that the fast films are just about adequately developed, but the slow ones are inevitably severely over-developed. (There is more about processing monochrome later in the chapter.)

'PRO' AND 'AMATEUR' LABS

For slide films, the big differences between pro and amateur labs are speed and cost, and (in most of the world) slide mounting. Quality may or may not vary, and while lost films are rare with either, they are generally easier to trace in the pro lab because of the smaller volume and more personal service.

Where the amateur lab takes two or three days or even a week or more, the pro lab will take two or three hours. Pro labs typically charge twice as much as amateur labs, and will not honour process-paid films, which must go back to the

diffuser with mixing chamber, cold cathode. Nowadays, diffuser enlargers dominate the market, but it is worth taking a quick look at the alternatives.

Point source enlargers will give maximum sharpness, but they also show up every scratch and mote of dust, so they are only for masochists: preferably, for masochists who don't mind oil-immersion printing, with the negative sandwiched between glass in a silicone oil which has to be cleaned off before the negative can be put away.

Condenser/diffuser enlargers are the ones that are normally given away, and they can be used for both colour and VC printing with discrete filters, either in a drawer or under the lens.

Diffuser enlargers with dial-in filtration (for colour or for variable contrast) are the standard today – they are what we use – but quite honestly, they make no real difference to image quality: they are merely more convenient than condenser/diffuser enlargers.

Cold cathode enlargers, which use a variety of fluorescent lamp as a light source, have a sort of mystical aura to them which is not, in our experience, particularly justified. Because the light is very diffuse, they are alleged to produce the closest effect to that of a contact print, but equally, if a diffuser enlarger has the final diffuser plate close enough to the negative, the difference is very slight. We have both cold cathode and diffuser heads for our 5x7in enlarger, and we almost never use the cold cathode head, not least because it does not filter very well for VC paper. Cold cathode heads also need to warm up: the initial composition and intensity of the light is not the same as it is when the head has been on for a while.

FEEDING BIRDS, ZUERICH
In the caption on page 32 we have sung the praises of the 6x8cm format; but it is worth remembering that many enlargers stop short at 6x7cm, and that even if your enlarger will handle 6x8cm, there is very unlikely to be a carrier for that format, so you will need to use built-in masking bars (where available) or to cut a black paper mask, if you want the ultimate in quality. HAND-HELD ALPA 12WA, 58/5.6 SUPER ANGULON, KODAK EKTACHROME EPN. (RWH)

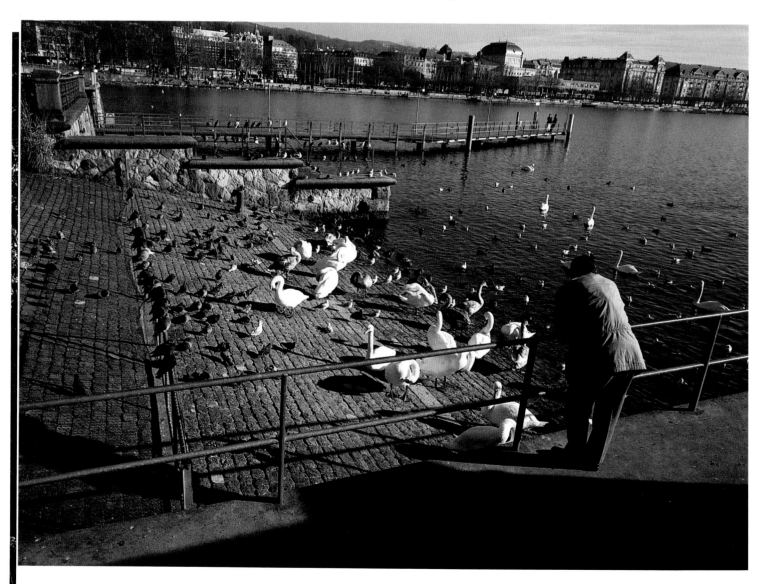

NEW YORK
*A reviewer of one of
Roger's books, many years
ago, complained about the
'contrasty, over-polarized
images'. He thereby
revealed first, that he had
not actually read the book
– Roger complained in the
text that polarizers were
too hard to use on
M-series Leicas – and
second, that he was
unfamiliar with the kind of
contrast and saturation
that Leica M-series lenses
can deliver.*
HAND-HELD LEICA M4-P,
35/1.4 SUMMILUX, FUJI RFP.
(RWH)

Light sources and the Callier effect

The grain in a negative does not merely block the light: it also scatters it, thereby effectively introducing extra contrast in proportion to the density of the image. The Callier effect is (predictably) most obvious in a point source enlarger, where the beam is most highly collimated, and least apparent in a cold cathode enlarger. Variations in the Callier effect are one reason why different photographers need different degrees of contrast in their negatives: formerly, film and developer manufacturers often used to recommend one development time for condenser enlargers, and another, longer development time for diffuser enlargers.

Because chromogenic films such as Ilford XP2 and Kodak T400CN have only a dye image, with no silver, they do not exhibit the Callier effect and will normally print at pretty much the same contrast in any enlarger.

Negative carriers

At least as important as the light source is the construction of the negative carrier. A perfect negative carrier would hold the negative dead flat without glass. A few do this, but it seems to be a matter of luck, even among the best enlargers. The next option is a single-glass carrier, where the film is against glass on one side but open on the other; and the third and final option is a double-glass carrier.

The disadvantages of any glass carrier are that there are two or four extra surfaces to gather (or seemingly, attract) dust, and that with some films and some glass carriers you will get Newton's rings, those infuriating oil-in-a-puddle rainbow rings which are caused when two very smooth transparent surfaces are in contact.

The disadvantages of glassless carriers are equally clear. They do not hold the film as flat, and worse still, some of them allow the negative to 'pop' as it warms up in the film gate. This is particularly vexing when you have focused your image carefully, only to see it pop out of focus just before you turn the enlarger off to put the paper in (or worse still, during the exposure).

Either type of carrier is a compromise, and some enlargers allow you to use either, depending on your mood and most recent bad experiences. Regardless of which type you have – and we have both – it is very useful to have sliding masks in the enlarger or carrier so that you can mask off any unwanted bright areas. This can greatly reduce flare (see below, under 'Lenses'). If you do not have sliding masks, then seriously consider cutting small black paper masks to size if you need to block off any large light areas.

Updating old enlargers

Earlier, we said that it is often possible to update old enlargers, and if you have a sound chassis with a good negative carrier, this may be the best option. New lenses are the most obvious investment, and often the best, but it may also be possible to 'bodge on' a new enlarger head. Our ancient 5x7in MPP Micromatic now sports a De Vere 507 dichroic colour head, one of the finest ever made, and it would be possible with many smaller-format enlargers to lash up a Meopta colour or VC head, which can be bought separately.

It is also worth knowing that some old enlargers are much better supported than others. De Vere can supply most parts for all but their very oldest enlargers, while in the United States, there are still plenty of parts even for very elderly Omegas, and old Beselers can often be updated.

ENLARGER LENSES

One of the most important investments you can make is in a good enlarging lens – but 'good' bears a lot of close investigation. First, there is the question of flare. Enlarger lenses seem peculiarly susceptible to pitting and grime with the passage of the years, perhaps because of the humid and sometimes chemical-laden environment in which they work. A good enlarger lens has a life of decades, but it will not last forever, and a lens which was state-of-the-art when it was new, thirty years ago, may well have lost its 'edge'. Old lenses (especially old, uncoated lenses) are normally a lot less contrasty than new ones, and flare also affects colour balance, adding a blue/cyan tinge in colour negative printing.

Second, there is the question of enlargement size. The bigger the enlargement, the better the

lens has to be. If you look at enlarger lenses from top manufacturers, you will see that they commonly offer at least two ranges. Look closely at the specification of the cheaper range, and you will find that lenses for 35mm are typically optimized for an enlargement size of around 5x or 6x, and those for roll film at around 4x. This equates to around 5x7in (13x18cm) or 6x9in (15x22cm) off 35mm, or around 10x12in (24x30cm) off 6x7cm. The more expensive range will be optimized for 8x or 10x off 35mm (8x12in to 10x15in, or 20x30cm to 25x40cm) and for maybe 7x off roll film (16x20in/40x50cm off 6x7cm).

At the smaller enlargement sizes, the cheaper lens may be just as good as the more expensive one. It may even be contrastier: we have a 105mm Meopta Anaret (three-glass) and a 95mm Computar (six-glass), and at up to about 4x, the Anaret is sometimes more pleasing. At 12x16 (30x40cm), the Computar is clearly pulling ahead, but if you do not print at such sizes, do you need to spend the money?

Third, there is the question of distortion. A more expensive lens will almost invariably render straight lines more accurately at the edge of the image, without bowing outwards (barrel distortion) or inwards (pincushion distortion). This is, however, likely to be visible only with certain subjects such as architecture: with portraits or landscapes, the effect is likely to be imperceptible.

Fourth, there is the question of evenness of illumination. A general rule here is that the longer the lens, the more evenly it will project an image from a given size of negative. This is, however, only a general rule: a high-quality 90mm lens, with six glasses and relatively large front and rear elements, may well equal or surpass the coverage of a 105mm of three-glass construction. A lot depends on the enlarger light source, too.

With any lens, there is likely to be an optimum aperture, as canvassed for camera lenses on page 52. Enlarger lenses are not particularly hard to design, so there is no reason why this should not be a couple of stops, or even one stop, down from maximum aperture. Certainly, stopping down unnecessarily will reduce definition, and many people reckon that their favourite enlarger lens has a very clear 'sweet spot' where it gives better definition than even ½ stop either side. It is well

PARIS
Today, we would not bother to make a conventional reversal print of a subject such as this, because we could get excellent results by scanning in the trans-parency and printing it with an Epson Stylus Photo. But for pictures with large areas of subtle highlight tone, or where shadow detail is important, silver still maintains the lead.
TRIPOD-MOUNTED NIKKORMAT FTN, 35/2.8 PC-NIKKOR, KODACHROME 64. (FES)

CHAPTER TWELVE

SILVER GELATINE PRINTING

Myth, prejudice and incomplete understanding are as common in discussions of printing materials and techniques as anywhere else in photography. Misconceptions are more common in monochrome, for the simple reason that with colour, you either follow the instructions or you get undeniably bad prints, while with monochrome, it is harder to make a complete mess of the picture as a result of following some guru's bad advice.

For this reason, it is easiest to begin with colour, and the first and simplest piece of advice is to use fresh paper and chemistry. Outdated materials may, depending on how the materials were stored, give anything from first-class results to a total disaster, with poor saturation, funny colours and crossed curves.

'Crossed curves' mean that you cannot correct a colour cast in both the highlights and the shadows. If you have neutral dark tones, and a magenta cast in the light tones, the price of getting rid of the magenta cast in the light tones is a green cast in the shadows. If both your film and your paper are suspect, you may be unable to distinguish which is causing the problem. If you cannot get a good print on fresh paper, it is the film; if you can get a good print on other paper, but not on the paper you are using, then it is clearly the paper.

COLOUR REVERSAL PRINTING

Printing from slides has several advantages, not least that you have the original slide as a reference. It also gives you the option of using Ilfochrome, still commonly known by its old name of Cibachrome, with its stunning quality and excellent archival keeping. Alternatively, you can use a conventional reversal paper, most commonly known as R-types. The status of the third reversal printing process, dye transfer, was unclear at the time of writing: it had been discontinued by Kodak, but there was some prospect of its being reintroduced by another manufacturer. If it comes back, it is arguably the most beautiful and permanent of all reversal processes, but it is time-consuming and expensive.

PRAGUE
This is a reversal print, without any unsharp masking. The original print is pretty good, but the whole idea of photo-mechanical reproduction from a reversal print is rather dubious: you are now looking at a third generation (slide–print–book) instead of merely second generation (slide–book), so it is questionable whether you can ever learn very much from such an illustration. Once again, looking at original prints is essential.
LEICA M, 90/2 SUMMICRON, FILM STOCK FORGOTTEN. (RWH)

Most colour materials are coated on a similar sort of RC base to monochrome papers, though a few are coated on a very glossy, very dimensionally stable, and very expensive polyester base. There are no mass-market fibre-base papers in colour.

Because you are dealing with a reversal process, colour adjustment is pretty much intuitive. If you have a blue cast, you dial in some yellow in order to get rid of it; if you have a magenta cast, you take out some magenta. For a lighter picture, you give more light, and for a darker picture, less. The only problem comes when you are already used to neg/pos printing, and start trying to make corrections 'backwards'.

Colour reversal printing is almost certainly the best option for the photographer who wants to farm out the actual printing, because there is not much scope for dispute on colour balance: either it matches the slide, or it doesn't.

Today, it is possible to buy two or even three versions of some reversal printing materials, in 'high contrast,' 'normal contrast' and 'low contrast'. For many purposes, these suffice, and indeed, 'normal contrast' is easily the best seller; but for the ultimate in contrast control (and, therefore, for the ultimate in quality) you need to try unsharp masking.

Unsharp masking

An unsharp mask is made by placing the transparency on one side of a sheet of glass; the masking film on the other; and making a thin, weak, slightly out-of-focus negative. This is then placed in the negative carrier in register with the transparency, and the sandwich is printed. The highlights of the negative (the darker areas) are in register with the highlights of the transparency (the lighter areas), while the shadows of the negative are in register with the shadows of the transparency. The contrast range is thereby magically compressed.

The whole process is less difficult than it sounds, but this is not the same as saying that it is easy. The biggest single problem is dust, and meticulous cleaning with anti-static brushes is essential. A less immediately obvious problem is image colour in the unsharp mask. Normally, a thin, weak negative will be brownish in tone, and the ·colour may also vary from the highlights to

CHOERTEN
Until 1999, it was difficult (though not impossible) to vary the contrast of colour materials in development. But then Paterson devised a split-developer system which allowed substantially independent control of density and contrast, by varying the times in the two baths. Some of the control available to Zone System users was suddenly available to colour print workers.
HAND-HELD ALPA 12 SWA, 35/4.5 APO GRANDAGON, 6X9CM, KODAK PORTRA 400VC. (FES)

MELON AND CAPE GOOSEBERRIES
Almost all our 'fine' monochrome pictures are toned. This is lightly bleached, then toned in a 5 per cent sodium sulphide bath, out of doors: a stink, but a beautiful tone on Ilford Multigrade IV.
LINHOF TECHNIKARDAN, 210/5.6 APO-SIRONAR-N, ILFORD FP4 PLUS. (RWH)

the shadows. You therefore need an appropriate developer to give a neutral image tone.

Fairly obviously, you need a panchromatic film: anything else would lead to differential masking of the various colours. To be honest, this is not an area which we have explored, and it is also an area where devoted – one might almost say, obsessive – technicians are constantly making small but worthwhile improvements both to technique and to convenience. If you want to go down this path, we would recommend Ctein's book, *Post Exposure* (Focal Press, 1998). There is also considerable scope for correspondence with other practitioners and for on-line investigation of their work.

ILFOCHROME

Ilfochrome actually uses a different colour process from most colour materials, namely, dye-destruction. In other words, instead of using dye precursors which are converted into dyes, the dyes are already present and are destroyed in proportion to the silver image. This is how it can be so permanent – and it is also why it cannot be processed in normal reversal-process chemistry. Despite the superlative quality of Ilfochrome, there are three factors which militate against it.

One is the cost: it is considerably more expensive than conventional materials, partly because of the polyester base (though a cheaper version is available on RC paper) and partly because of the unique and inherently expensive nature of the process. Being made in Switzerland doesn't help, either.

The second is the speed: it is a lot slower than conventional materials, so you need long exposure times, even with powerful light sources.

The third is that the beautiful shiny surface is easily marred, though this is pretty much a case of exercising reasonable care in processing.

If you can afford it; if you can already turn out excellent transparencies; if you are willing to try unsharp masking; and if you do not mind the long exposure times (which are rather less of a problem with larger formats, where you can pour more light through the transparency): if you can meet all these conditions, then Ilfochrome probably offers one of the quickest and best off-the-shelf solutions to the search for quality that there is.

OTHER CONVENTIONAL REVERSAL MATERIALS

Much the same observations apply to other reversal materials as to Ilfochrome. On the plus side, they cost less and are faster; but on the minus side, they are less permanent and (for the most part) less attractive. Our own view is that if you want high-quality reversal prints for exhibition, it probably makes the most sense to use Ilfochrome, with unsharp masking.

DYE TRANSFER

Dye transfers begin with a set of three separation negatives, made from the original transparency. Each of these is then contact printed or enlarged on to special matrix film which is developed in a tanning developer (see page 119). The untanned emulsion is next washed away with hot water, leaving an image in which the thickness of the gelatine is in direct proportion to the intensity of the image.

The three matrices are then 'dyed up' in cyan, magenta and yellow dyes respectively, and rinsed in acetic acid to remove the surplus dye. At this stage, contrast in the middle and shadow tones can be adjusted by treating the matrices with sodium acetate; highlights can be brightened with Calgon; and overall contrast can be controlled by varying the strength of the acid rinse.

The matrices are brought in turn (and in register) into contact with the sheet of dye transfer paper, which absorbs the dye out of the matrices. As may be guessed, the process offers as much scope for error as it does for control, which is one reason it was never widely popular. The densities of the separation negs must be precisely matched; the matrices likewise; the matrices must be washed at the same temperature, or they will expand differentially and there will be colour fringing; the dyes must be checked, and their intensities adjusted (if necessary) by adding acetic acid; the matrix controls must be in step; and the images must be transferred in register.

On the other hand, both colour and contrast can be controlled within very wide limits, and the matrices may be used to produce multiple copies – perhaps as many as 150 – and both permanence and quality can be superb. If you have the patience and the time, and if the materials are available, this is a superb process – but it is also one which lends itself to a preoccupation with the process rather than with the results, if the photographer is that way inclined.

COLOUR NEGATIVE PRINTING

Surprisingly little needs to be said here. The materials are getting better all the time, and all are good. Contrast can be controlled in a number of ways. Some control is possible at the negative developing stage (more development means more contrast, though you will have to do your own C-41 as few commercial labs will do 'push' and 'pull'); some print materials are available in different contrast grades; and the Paterson three-bath chemistry, described in the caption on page 155, allows still further contrast control.

To a very large extent, colour negative printing is a question of following the manufacturers' instructions, and taking considerable pains at each stage.

BOATS, MARSAXLOKK, MALTA
To many people, infra-red means the soft, grainy look of Kodak materials, usually printed on FB paper. Frances chose glossy RC (MG IV) to give a 'hard edge' look for this picture shot in Marsaxlokk on Ilford SFX with an IR (T$_{50}$ = 715nm) filter. There is a colour picture of her taking the shot on page 55.
CONTAX RX ON TRIPOD, 35/2.8 PC-DISTAGON.

NOWROJEE'S (ESTD 1860)
Nowrojee's in Dharamsala is the longest-established shop on the northern sub-continent: a wonderful combination of museum and working shop. The advantage of shooting on colour negative – this is Kodak Portra 400 VC – is that filtration for colour balance can be done in the darkroom, rather than having to be done at the time as it would with slide film: here, there is daylight, tungsten and fluorescent, hopelessly mixed.
ALPA 12 SWA TRIPOD-MOUNTED, 35/4.5 APO GRANDAGON ON 6X9CM BACK. (FES)

MONOCHROME PAPERS

There is absolutely no doubt that some monochrome papers are better than others, with a higher maximum density and a more pleasing texture. There is equally little doubt that even where it is impossible to describe one paper as 'better' than another, there are very significant differences. For example, we find that Ilford Multigrade IV Warmtone differentiates dark mid-tones better than Ilford Multigrade IV – but Multigrade IV may be a better choice in some pictures where highlight detail is important. Nor can one deny that choice of developer can make an immense difference to image tone and even to the tonal range. The most surprising (but equally incontestable) truth is that none of this seems to matter very much: a paper which one photographer finds completely unusable may well, in the hands of another, produce indisputably superb prints.

This leaves all photographers on the horns of an uncomfortable dilemma. It is flatly impossible to try every combination of paper and developer on the market – but hitting upon the perfect combination is very much a matter of luck. All one can do is to make it one's business to learn as much as possible, in order to be able to evaluate what people say and write, and in order to understand what is happening.

THE 'SILVER RICH' MYTH

An enduring myth among camera-club 'experts' is that the best papers are 'silver rich', that is, they have more silver halide per square centimetre, also known as a higher coating weight. This is completely and utterly untrue. A great deal more depends on how the emulsion is designed and used, than on the amount of silver halide in the emulsion.

There is of course a minimum amount of silver which is required to give a good maximum black, but once you have that minimum, you will not see any benefit from more. The important thing is covering power, which depends principally on crystal size but is also influenced by the binder/halide ratio. Put crudely, smaller crystals pack closer together and give a higher covering power, and the less binder you use, the closer the crystals can pack. Most modern papers use a combination of gelatine and synthetic latexes as a binder, though a few still use only gelatine.

Actual coating weights vary from around 0.5g per square metre (gsm) to over 2.0gsm; at the time of writing, most variable-contrast papers from major manufacturers were coated at about 1.6gsm, with graded papers in the 1.0 to 1.4 range. Maximum densities of untoned prints typically ran at around 2.15 to 2.30, with no particular correlation between density and coating weight; choosing an example from some years ago, a contact paper with a coating weight of 0.5gsm gave a maximum density about ½ stop (D=0.15) greater than a bromide paper with a coating weight of over 2.0gsm.

Although it is obviously in the interest of paper manufacturers to reduce silver content in order to save money, the cost of silver is a very minor part of the cost of the whole manufacturing process, and at least one manufacturer cheerfully admits to using more silver than is actually needed, purely as a marketing tool: if people want to believe that 'silver rich' papers are essential, it does not cost a fortune to pander to them – especially if you can charge a premium for doing so.

It is also worth making the point that while the eye can spot tiny variations in density in the highlights, as little as D=0.005 (which is better than most densitometers can measure), it is much less sensitive to any variations in shadow density. Even under glaring light, variations of 0.10 are the least that are detectable, and in normal terms, 0.15 (½ stop) is what is needed to make a significant difference. Most maximum density variations are less than this.

BROMIDE AND CHLORIDE PAPERS

As with 'silver rich' papers, there is a great deal of mythology surrounding chloride, bromide and chlorobromide papers. Today, it is possible to grow chloride, bromide and chlorobromide crystals to much the same size, and as it is crystal size (and hence silver grain size) which principally influences image tone, it is possible to make warm-tone bromide papers and cool-tone chlorobromides. In practice, a number of other factors influence the choice to use the different halides. Sensitivity is an obvious one, but as chlorobromides can be dye-sensitized to more than adequate speeds, it is not really all that important. Another factor is the interaction of the halide crystals with other chemicals in the emulsion; for example, with the rhodium salts which are used to govern paper grade in graded paper (more rhodium means more contrast).

TONING

Toning is widely used to improve maximum density, and it is quite possible with a little gold or selenium toning to get another ½ stop or more of maximum density, lifting the D_{max} of a paper in the 2.15 to 2.20 range to 2.30 or better. As usual, there is a law of diminishing returns: if the D_{max} is 2.30 to begin with, you will be lucky to see 2.40 after toning.

DEVELOPERS AND IMAGE TONE

Development has a great influence on image tone, and the interaction of a given emulsion with a given developer is by no means predictable. We use quite a lot of Ilford Multigrade Warmtone, developed in Agfa Neutol WA to get a really warm image; in some other developers, the difference between Warmtone and the (rather cheaper) plain-vanilla Multigrade is not worth worrying about, though the cream base of the Warmtone still creates a somewhat different impression. A good deal depends, too, on the light under which the print will eventually be seen: in

CHAPTER THIRTEEN

ADVANCED PRINTING – AND BEYOND

**GUEST HOUSE,
NORBULINGKA**
*All printing is a matter of
interpretation – and
sometimes, you have to
try different interpreta-
tions, to see which one
works best. Which of these
two (fairly subtly) different
interpretations do you
prefer: the one with the
extra detail in the sky-
lights, or the 'straight' print?*
ALPA 12 SWA ON TRIPOD,
35/4.5 APO-GRANDAGON
ON 6X9CM KODAK PORTRA
400VC. (FES)

With conventional silver halide printing, there are relatively few hints and tips which matter much. Some are almost painfully obvious: others are less so. Perhaps the most important is print size.

As already mentioned in Chapter 2, we increas-ingly believe that the key to making really good black and white enlargements is to choose your enlargement ratios carefully. They must either be small enough that there is no evidence of the half-tone effect, or large enough that the grain is a clear part of the image. In between, there is an unhappy no-man's-land where sharpness may be entirely adequate, but tonality suffers.

In practice, this means that we will normally print at 5x or below, or 10x or above. These are by no means absolutes, and they vary from film to film, but as a general rule, we find that we get the best pictures this way. With 35mm, in particular, we find that we can achieve a result which is reminiscent of a contact print from 5x7in (13x18cm) by using Ilford Delta 100 or XP2 Super, and enlarging just 5x (cropping the long dimension slightly, of course). We also find that making a deliberately small print has more visual impact than making an all-too-familiar 8x10in.

With 44x66mm negatives from Roger's preferred Alpa configuration, the same enlarge-ment ratio corresponds to about 8x12in (20x30cm) (typically on 12x16in/30x40cm paper), while Frances can go to around 24x36cm (11x14in), because she favours the 6x9cm format (actually 56x84mm). With 4x5in film, a 16x20in (40x50cm) enlargement is little more than a 4x enlargement, and you can get wonderful tonality even from Ilford HP5 Plus at ISO 400.

In colour, we find the half-tone effect less obvious, and actual, perceptible grain is what really matters; but once grain arrives, we find it significantly less palatable than we do with 35mm. This means that enlargements as big as 10x are entirely feasible from the best current colour films, typically ISO 100 or less – and at this point, image sharpness is as important a point as tonality, so only the finest lenses will do. Given that we use Leitz, Zeiss and Nikon, this is hardly a major problem, but we try to follow all our own advice as given in Chapter 4 in order to get the maximum possible sharpness.

For colour enlargements over about 10x12in (25x30cm), we prefer whenever possible to use medium format, principally on the grounds of sharpness: ISO 400 film gives perfectly adequate grain up to about 5x (12x16in/30x40cm off 6x7cm or bigger), while ISO 160 or slower is preferable for still bigger enlargements.

STREET, BIRGU, MALTA
The smaller print is the work print, on grade 2½. The upper right is burned out, and differentiation of the building on the right and the moulding over the door is much poorer than in the final print, where pre-flashing at grade 1 and local burning in the upper right have allowed better tonal differentiation at grade 2 and the retention of much more detail.
CONTAX RX ON TRIPOD, 35/2.8 PC-DISTAGON, ILFORD XP2. (FES)

WORK PRINTS

A major difference between skilled printers and beginners is that skilled printers normally begin with a 'work print', instead of trying to get a perfect picture, first time.

The vast majority of pictures are likely to need at least some burning and dodging; some may need pre-flashing; and there is always the possibility of selective bleaching afterwards. It is easiest to work out precisely what they will need if you first make a reasonably 'straight' print, let it dry, and use that as a basis for deciding on what more is needed.

BURNING, DODGING AND PRE-FLASHING

There is little point in saying much about burning and dodging, as easily the best approach is simply to illustrate the techniques with pairs of prints. Likewise, there is not very much to say about

pre-flashing. The technique of pre-flashing to overcome inertia has already been discussed on page 146.

The big advantage of pre-flashing is when you want to hold highlight detail which is on the negative, but seemingly just out of reach on the print. Pre-flashing will quite magically allow you to hold that detail without dropping to a softer grade of paper and without increasing exposure,

EAGLE FOUNTAIN
The monochrome print is the original work print, all-in off a 35mm Ilford SFX negative, using a 100/2.8 Makro-Planar on a Contax Aria. The toned print is cropped; heavily burned on the upper right, to retain texture in the stone; dodged in the wings to retain detail (look at the cross on the right wing, camera left); and toned in selenium for the image colour. (FES)

YOUDON AT THE TARAGARH PALACE
There is little point in showing 'before' and 'after' pictures of this shot, because the differences would be very hard to spot in reproduction; but in the pre-flashed picture, as reproduced here, there is much more detail in the window at the top of the picture, and some texture (which is otherwise entirely lacking) in the topmost of the three lampshades.
ALPA 12 SWA ON TRIPOD, 35/4.5 APO-GRANDAGON ON 6X9CM, ILFORD HP5 PLUS. (FES)

both of which may result in a 'muddy' print and the latter of which will also block up shadow detail. The softer the initial grade, the more successful pre-flashing is; with 00, 0 and 1, it is

really useful, but by grade 5, the effect is unlikely even to be perceptible. It can also be used in colour, though from our experience, it is more successful in mono.

SELECTIVE BLEACHING

The name 'liquid sunshine' is sometimes given to Farmer's reducer, a mixture of potassium ferricyanide ('pot ferri') and sodium thiosulphate ('hypo'). The name comes from the magical way it can add 'sunny' highlights to monochrome prints.

It is normally made up as two stock solutions, the first consisting of 10 per cent pot ferri (50g in 500ml of water) and the second of 20 per cent hypo (200g in 1 litre of water); for use, one part of A and 5 parts of B are added to 30 or more parts of water (for example, 5ml of A, 25ml of B, and 150ml of water). The mixed reducer has a life of about a quarter of an hour, and must always be mixed fresh.

Local bleaching is normally done with a brush (which should not be used for anything else) or with a cotton swab, usually on a wet print. The action of the reducer is arrested by washing, so bleaching should always be stopped slightly before the aim-point is reached. Some papers display

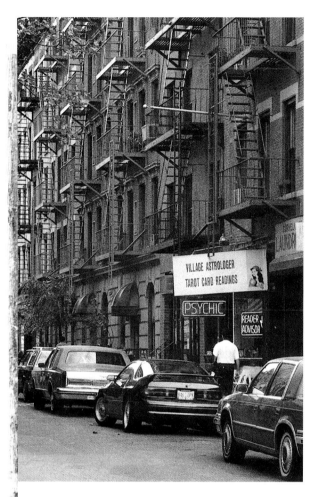

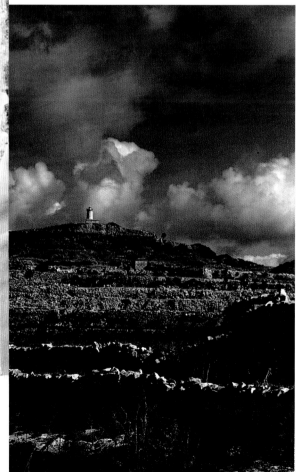

excessive colour shifts when bleached locally; this can only be discovered by trial and error, preferably on an unimportant print. After local bleaching, the paper must be washed in the same way it is after fixing, or staining will result.

TONING

In the 1960s and even 1970s, it looked as if toning might die out completely. Today, depending on whom you believe, 60 per cent or more of prize-winning prints (whether commercial or salon) are toned to a greater or lesser degree.

Some are toned merely to improve the maximum density, as noted on page 159; either gold or selenium toners, following the manufacturers' instructions, are all that is needed.

Others are toned for improved archival permanence. Again, gold or selenium will do this with negligible or modest colour shifts, while sepia toning will give a much more noticeable shift. Then there is toning just for colour, with sepia or with other toners which may or may not improve the archival quality of the image; most don't.

Generally, using toners is a matter of following the manufacturer's instructions, but three points need to be made. The first is that an almost infinite variety of effects may be achieved by partial toning, or by dual-toning in first one toner, and then another. Some of these results are quite unexpected, such as the peachy-red colour which you get by gold toning after sepia. The second is that some toners are much easier to use than others. In particular, blue toners are incredibly sensitive to the slightest splash of anything alkaline, especially developer, which will remove the blue tone completely; with some waters, you may even need to add a little acetic acid to the working solution in order to get a decent blue. The third is that not all sepia toners are created equal, and that unfortunately, the attractiveness of the results seems to be in inverse proportion to the unpleasantness and inconvenience of the process.

Although we have never tried it ourselves, some of the finest sepia tones we have ever seen have come from the hot hypo-alum process, where the prints are toned for 10 or 15 minutes in a hot (50–55°C/120–130°F), stinking, poisonous solution of hypo and potassium aluminium sulphate (potash alum).

Our best sepias have been with potassium

VILLAGE ASTROLOGER, USA
This photograph shows why, for years, we did not use HP5 Plus; we had not found the right developer. Here, the tonality is gritty, 'mean streets', and this is not an effect we often want. But with Paterson FX39 or Ilford DD-X 1+9, and slightly more generous exposure (as a result of spot metering), we get a tonality which we really like. To get the right print, you have to start with the right negative.
HAND-HELD NIKKORMAT FTN, 35/2.8 PC-NIKKOR. (FES)

SELECTIVE BLEACHING
This picture also appears on page 93, in two forms – all-in and cropped – but here, Frances burned the sky very strongly (which led to rather a flat, muddy-looking shot) and then used pot ferri to brighten up the clouds. A somewhat similar effect might have been attainable with filtration, but pot ferri allowed a dramatic picture to be extracted from a fairly indifferent negative.
TECHNICAL INFORMATION ON PAGE 93. (RWH)

IMAGE CAPTURE

We have already touched upon digital cameras in Chapter 3, and there is little more to say here, except that an image from a 6-megapixel chip contains about one-third as much information as a 35mm Kodachrome (estimated at around 20 megapixels); a 1.3 megapixel chip therefore contains about one-fifteenth as much. It is conceivable (though by no means certain) that instant-capture digital image chips will one day equal 35mm; but given the tiny market of photographers who want quality even that good, let alone better, it seems to us profoundly unlikely that there will ever be chips which can equal the quality of even 645, let alone 6x7cm. Scanning digital backs are another matter, and already equal film quality; but they can only be used with stationary subjects.

It may be worth adding that as we were working on this book, two of the magazines for which we write issued instructions saying that they did not want any more digital image submissions, from anyone, wherever possible; the quality they were getting, after two or three years of experimenting with accepting digital submissions, was simply not adequate.

They were talking about the results from film scanners which cost at least as much as a good, mid-range SLR, hooked up to computers which cost several times as much again; and still they were not happy with the quality. They wanted to scan the images themselves, on drum scanners which cost as much as a good motor-car, and to manipulate the resulting seriously large (50 to 100 megabyte) files in their own powerful computers.

In other words, although electronic 'processing' is now the norm in publishing, the difference between professional equipment and amateur equipment is like the difference between a Formula One racing car and a family runabout – and even at that, the best photomechanical reproduction cannot match a good silver gelatine print.

FUTURE IMPROVEMENTS

We had originally intended to go into such technical matters as scan depth and scan resolution, both true (optical) and interpolated; but then we realized that from the point of view

ROGER WITH LEICA
One of the things that digital manipulation can teach you is how little information you actually need to convey a familiar image. Here, Roger's beard and Leica are clearly recognizable. This sort of understanding can also be carried over into conventional imaging.
NIKKORMAT FTN, 90/2.5 VIVITAR SERIES 1 MACRO, PATERSON ACUPAN 200; MANIPULATION IN ADOBE PHOTOSHOP WITH A PATERSON DIGITAL LAB. (FES)

GIRL AT THE TUDOR HOUSE, MARGATE
We find our computer more use for rectifying mistakes than for creating quality in the first place. This film was dried in a recently acquired second-hand drying cabinet, and was appallingly speckled with dust. It was cleaned up in Adobe Photoshop with the Clone tool. Roger lost count of the number of 'hits' after 250 or so...
LEICA M2, 35/1.7 VOIGTLANDER, KODAK E200 PUSH 1 AT EI 320.

of this book, there was absolutely no point in doing so. Yes, we have seen truly spectacular quality; but the original images were captured either with scanning-back cameras, or on silver halide which was then scanned with a high-end scanner, and the final prints were made with a 'paper writer' which prints directly on to silver halide paper, using lasers or LEDs. Either way, you are looking at the price of at least one new Rolls Royce, and possibly at the price of two.

Even if prices fall like a stone, it will still be several years before digital imaging can seriously challenge silver halide when it comes to maximum quality at a realistic price. At the time of writing, silver not only delivered better quality than digital: it delivered better quality at between one-tenth and one-hundredth of the price. And we are sure that it will be quite a while before the balance is tipped the other way.

THE USES OF ELECTRONIC IMAGING

Despite the lamentation above, we believe that digital imaging does have a place alongside conventional photography, for four reasons.

The first is that a digital camera allows cheap, easy practice in taking pictures and making work prints – and practice is the single most important factor in becoming a better photographer. The only drawback is the risk of shooting a wonderful picture, and then being unable to make a decent print any bigger than postcard size.

The second is that there are no absolutes in photography of any kind. A sufficiently great picture – whether it be well observed, well composed, or well assembled from disparate elements in the computer – can transcend its technical imperfections, or even transmute them into desirable qualities, just as grain or high contrast or blur or any other 'fault' can be used creatively with silver halide.

The third is that there are things which can be done with a computer which simply cannot be achieved by other means, or at least, which cannot realistically be achieved by other means.

The fourth is that there are always pictures where conventional quality just does not matter: snapshots, pictures for transmission over the Internet, catalogue shots... The list goes on.

This last point is why we mention digital imaging again – and not so disparagingly – in the next chapter. We are more than happy, however, to let time be our judge on the relative advantages of silver halide and digital imaging. At the very least, we believe that there are qualities in silver halide which cannot be equalled with digital imaging, and that these advantages may well endure without limit. After all, painting was not killed off by photography, nor radio by television.

NOVA HAND LINE
This hand processing line for 4x5in film, described on page 128, was for some inscrutable reason photographed on a red grid. 'Cutting out' in Adobe Photoshop took about 20 minutes, which is much better than would have been possible using masking film and an airbrush or any other conventional approach. The product shot has since been re-taken on a more conventional background!
COURTESY NOVA.

SOPHIE MUSCAT-KING
Without the digital manipulation, this is a fairly ordinary 'dressing up' shot. To achieve a similar effect with conventional chemistry would be expensive and time-consuming. The great advantage of digital imaging is that it allows you to play around with an idea, without spending anything on materials, until you get an effect that you like – at which point you can either print it out electronically, or take the traditional silver route.
HAND-HELD CONTAX G2, 90/2.8 SONNAR, PATERSON ACUPAN 200 MANIPULATED IN ADOBE PHOTOSHOP USING A PATERSON DIGITAL LAB. (RWH)

CHAPTER FOURTEEN

SELECTION AND PRESENTATION

It is always tempting, when you are asked which is your best picture, to say, 'I don't know – I haven't taken it yet.' There are also two conflicting tendencies when it comes to looking at your own recent work. One is to think it is your best ever, because the enthusiasm is still fresh in you. The other is to be convinced that you are losing your touch, because you are too close to it, and you have not yet managed to separate your feelings about the subject from your feelings about the picture, as described on page 14.

To make matters still worse, photographers are not always the best judges of their own work: more than once, we have been surprised when an editor has made a lead picture of an image which we regarded as little more than a makeweight – but which we have to admit was an excellent choice on the page.

You have to fight with all of this when it comes to showing your work. As the old saying goes, you are not judged by the pictures you take: you are judged by the pictures you show. Showing failures,

and showing too many images, are the greatest errors that most people make when they first begin to show off their photographs. So how do you select your pictures?

INITIAL SELECTION

The first round of selection is easy enough: you simply winnow out all the technical failures. Even here, though, you have to be careful. How do you judge a 'failure'? There are pictures which are not as sharp as they might be, or where colours are a bit funny, but where sheer impact makes up for the deficiencies. But equally, you can try and kid yourself that a picture which is not really good enough is saved by its composition, or whatever, when in your heart of hearts, you know that it isn't. If you really aren't sure, give yourself the benefit of the doubt.

The second round is only a little more difficult. Where you have several identical or near-identical pictures, select just one of them. Remember, too,

TROGLODYTE HOUSE, GOZO
There is a difference between a batch of similar pictures of the same subject, and a set of pictures which show different aspects of the same subject. The former, no one wants to see; the latter may well be more interesting than a portfolio made up of substantially unrelated pictures. This is the basis of the 'picture essay'. Other pictures of the same place appear in this book as the Frontispiece and on page 125; the technical information is identical.
(FES)

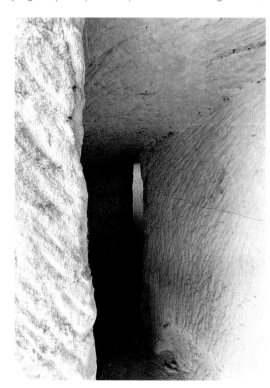
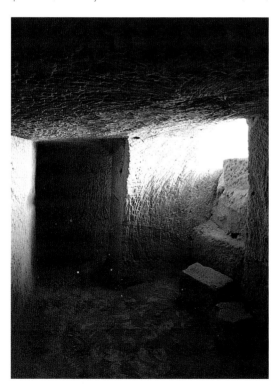

that pictures which are significantly different for you may be substantially identical for someone else: if they are (for example) of the same people in the same setting, the fact that there are slightly different poses may be of limited interest.

The third round is more artificial. Count the number of pictures you have – and reduce it by an arbitrary percentage, at least 10, and maybe as high as 50. Initially, we very strongly recommend that you select no more than ten pictures in all, or a dozen at the outside, as this greatly reduces the risk of boring the person to whom you show your pictures.

The value of this third round is that it forces you to ask some slightly harder questions than you needed to ask in the first two. What were you trying to say? Were you successful in saying it? Why should this picture be included, rather than that one?

REVELATIONS

Now is the time to show your pictures – but not to everyone. Show them to someone whose opinion you respect; who will, you hope, be reasonably honest; but who should not, with any luck, be too hard on you. They should be an experienced photographer: if they are not, they may hardly notice technical shortcomings which are, in the context of this book, very significant. Ask them to separate their criticism, as far as they can, into an aesthetic strand and a technical strand.

We recommended a maximum of ten or twelve pictures because, if the pictures are really good, then they will want to see more – but not necessarily immediately. Even the finest pictures can rapidly become cloying; one's senses are soon overloaded. If the pictures are less than stellar, or if you have chosen the wrong person, then ten will be plenty for your critic to venture useful opinions on how they might be improved; any more will induce a rapid sinking of the heart, in one party or the other or both.

Pay due attention to what they say, but remember that everyone has his or her own hang-ups. We might well criticize a picture for being over-enlarged, where someone else might say that it would look better if it were bigger. Then there are the die-hards for whom grain is anathema, or who refuse to take 35mm seriously. Others will

take the opportunity to hop on to their hobby horse and tell you what you should be doing, whether it is using their favourite film or developer, or buying a new camera or lens.

Try to separate the constructive criticism from the chaff. Some problems can easily be remedied, either next time you shoot, or by remaking a print: sloping horizons, for example, or inadequate or excessive contrast. Other criticisms may be fair enough, but you may not be able to do anything about them, whether for financial or other reasons: switching to another format, perhaps, or travelling more – or standing in the middle of a

SWEEP
Subject to the limitations imposed by sharpness, this picture works pretty well at almost any size, from a postcard (or smaller) to an exhibition print. Why? It is hard to say – except that it partakes of both record photography and portraiture.
HAND-HELD LEICA M2, 90/2 SUMMICRON, KODAK PJ 400. (RWH)

there are the things that are simply irrelevant, either for all time, or for now.

There is a great deal of overlap between the categories, of course, and your views may change over time; but the important part is to think about each criticism (including favourable comments) carefully, giving them due weight, but no more.

Up to this point, you have not had to worry too much about presentation; you can show your transparencies on a light box, or use reference prints from the local mini-lab, or whatever, because you are trying to get feedback from a fellow photographer.

As soon as you start showing your pictures to a larger and more critical audience, however, you need to start thinking about how your photographs are presented. A great deal will depend on what medium you are using (slides, prints or electronic) and on whom you want to look at the pictures.

SLIDES

The classic slide presentation is the slide show, and there are a number of simple rules which will make the presentation smoother and more attractive. The ten most important are given in the panel, and similar considerations can be applied to video displays, insofar as they can be (in effect) slide shows on a screen. If you are making up

▲ PLOUGH ARGYROTYPE

As a conventional picture, this is rather dull; but presented as an Argyrotype, it has a timeless quality, like a glimpse of the past. While it is true that all too often, 'alternative' processes are used in an attempt to save inadequate pictures, it is also true that the right subject, shot with the appropriate process in mind, can be very effective.
MPP MK.VII, 150/4.5 APO LANTHAR, ILFORD FP4 PLUS. (RWH)

canal, or shooting at dawn in a location which opens at ten in the morning.

Then there will be the points about which you have mixed feelings. For instance, a separate, hand-held meter is not particularly expensive, but do you want one? Do you actually understand their criticism? On this point, remember that you may come to understand more as you improve. Could you actually work in the way suggested? For example, some people will tell you that you should note every exposure, with details of camera and lens and aperture and shutter speed. Maybe it works for them, but will it for you? Such a method certainly wouldn't work for us. And then

a slide show which you expect to show many times, seriously consider glass mounts to help protect the slides from damage.

To present slides for publication, the multi-pocket slide sheet is probably the best idea, ideally with black frame surrounds. Unless the demands of sequencing override the need for design, try to avoid putting bright slides next to dark ones. We make a conscious effort to have the lightest slide in one corner, and the darkest in the corner diagonally opposite, with a gradation in between. Never use glass-mounted slides for publication or competition entries: the risk of breakage and subsequent damage is just too great.

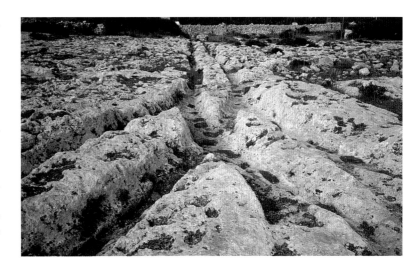

CART TRACKS, MALTA
A picture of this type can hardly stand on its own; it is an illustration, not a pictorial image. What is interesting about it is that these 'cart tracks' were made thousands of years ago, before the invention of the wheel, by stone-tipped wooden travois. *Centuries of dragging loads along the same routes dug these tracks, which have since weathered to the point where they need some explication merely to be recognizable.*
LEICA M2, 35/1.4 SUMMILUX, FUJI ASTIA. (RWH)

TEN RULES FOR SLIDE SHOWS

1. KEEP IT BRIEF Ten minutes is a good length; 15 is a sensible maximum; and 20 is an absolute maximum. Even the best slides in the world start to pall after a while.

2. STRUCTURE IT You need a beginning, a middle, and an end. The approach can be chronological or thematic or even based on shapes and colours, but there has to be some sort of structure.

3. HAVE THE COMMENTARY AT YOUR FINGERTIPS 'Ums' and 'ers' do nothing to enhance a presentation; you need a prepared patter. Use notes if you have to.

4. DON'T LEAVE SLIDES UP FOR TOO LONG Only if you are talking about a specific picture, such as how it was lit or exposed or composed or whatever, should it be on the screen for longer than 8 or 10 seconds. Unless there is a good reason, it should not be up for much over 5 seconds.

5. DON'T TRY TO GET TOO MUCH IN If at all possible, illustrate ten points with ten slides, not with one slide which stays on the screen forever.

6. DON'T SWAP ORIENTATIONS Try to keep all slides either landscape format or portrait. If you have to switch, try for a sequence of one format, then a sequence of the other, rather than dotting back and forth.

7. AVOID SUDDEN BRIGHTNESS CHANGES Unless you are doing it for a particular effect (which is unlikely to be successful), don't suddenly go from dark to light, as it will dazzle the audience, and don't suddenly go from light to dark, as they won't be able to see what is going on. Use a 'filler' slide as transition, if need be.

8. DON'T CHANGE FILM STOCKS UNNECESSARILY Not changing them at all is a counsel of perfection, but switching from one stock to the next can be all too obvious if, for example, you switch from Kodachrome 25 to Imation 640T and then to Fuji Astia.

9. CHECK BEFORE YOU SHOW Make sure there are no upside-down, or backwards, or out-of-sequence slides. We carry our shows in a Kodak Carousel, which we test before we set out.

10. BLACK OUT THE ROOM WELL It will vastly increase the impact of your slides.

◄ **BOAT ON LAKE, AUSTRIAN ALPS**
This picture has everything — except composition. Because the boat is almost dead in the middle, there is a curious lack of dynamism. On their own, exposure, sharpness and colour are not enough.
LINHOF TECHNIKA 70, 105/4.5 APO LANTHAR, KODAK EKTACHROME 64. (RWH)

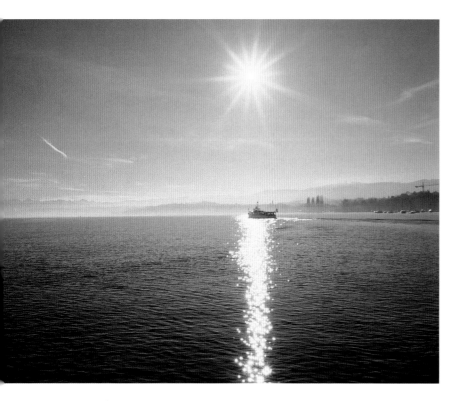

ZUERCHER ZEE
It is sad, but true, that if you bracket shots of a changing subject, you will all too often find that the best exposure and the best composition are not on the same shot. Another exposure in this sequence has more saturation, which looks better, but (of course) the ferry is in a different place.
The exposure, on 6x8cm Kodak Ektachrome EPN, was guessed.
HAND-HELD ALPA 12 WA, 58/5.6 SUPER ANGULON. (RWH)

MNAJDRA ▶
Even with-out any explanation, this picture has a certain fascination: it is pictorially (reasonably) attractive, even if we do not know that these ruins are around 50 centuries old, though the explanation adds to its merit. To hang on the wall, however, Roger (who took this picture) suspects that it would be more successful in monochrome.
LINHOF 'BABY' SUPER TECHNIKA IV ON TRIPOD. 105/5.6 APO SYMMAR, 6X7CM, FUJI ASTIA.

operators are fairly lazy, so the print may lose some information near the edges; and stick a label on the print, with the necessary information. We use LabelBase, as already described for slides. Anything other than glossy paper may not reproduce well: scanners cannot necessarily handle matt or textured surfaces. Consider making transparency copies of prints where this could be a problem.

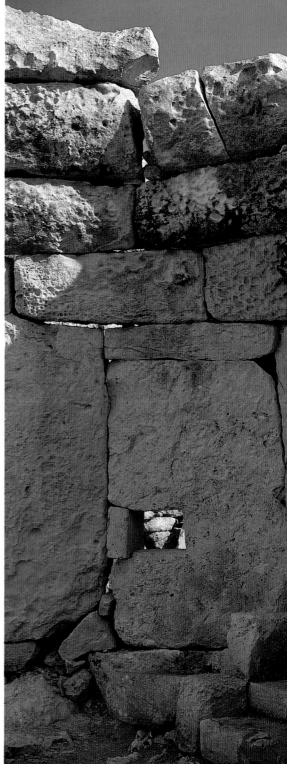

For individual slides, black paper masks with appropriately sized cut-outs are generally best; protect the slide with an acetate sleeve over the whole thing.

Label all slides, whether for publication, competition or a slide show, with your name, address and copyright claim, and (if necessary) with a caption or identifying mark. We use LabelBase, a computer program which allows us to put up to four lines of text on to a label which will fit easily on to a slide mount.

When it comes to prints, the way in which you present them will depend on whether you are setting up an exhibition, showing off your portfolio, or submitting pictures for publication or for a competition. It is easiest to deal with these in reverse order, as the elaborateness (and expense) of presentation goes up at each stage.

PRINTS FOR PUBLICATION

For publication, all you need is 8x10in unmounted glossy pictures. Almost all the prints in this book were reproduced from 'ten-eight glossies'. You can go to A4, but anything bigger will not win you any friends: the prints are simply too big to handle in bulk. Likewise, mounting will preclude scanning on a drum scanner. Leave a small border for handling and dog-ears; remember that many scanner

Prints for magazine and similar competitions are normally required in the same format as for publication; prints for competitions based around exhibitions may need to be mounted, as described below. With any competition, do not assume that you will improve your chances by doing something more elaborate than the rules call for. Often, you will simply row yourself out of the competition; at best, your efforts will be ignored.

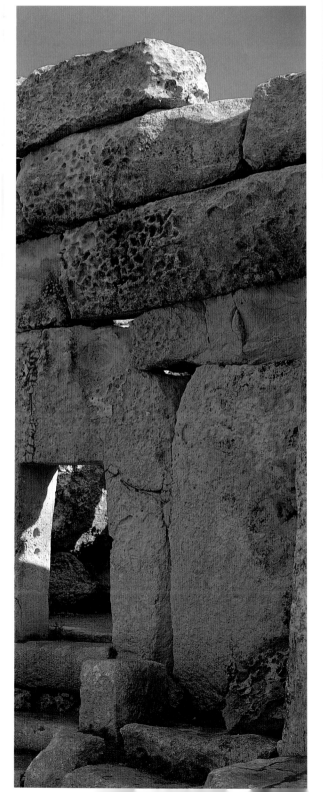

PORTFOLIOS

For a portfolio, arguably the best approach is lamination, as this helps protect your pictures against inconsiderate handling. On the down side, it can also detract from their impact, especially if you are into fine monochrome printing, and it means that the picture has to be reprinted if it is wanted for any other purpose. Also, laminating is not cheap. You may therefore decide to go to window-mounts or dry-mounted images, as described below.

Choose a standard card size: 10x12in (25x30cm) is as small as you could decently go, while anything larger than 12x16in (30x40cm) is likely to be inconveniently large. Get a good, solid portfolio case, and show your 'book' as loose sheets. You

PAUL AND GUITAR
It is hard to look at this picture without smiling: we have all had the experience of someone suddenly making a face like this, when we least expect it. The composition breaks every 'rule' in the book – which all goes to show that 'rules' are not everything. Technical quality (sharpness, grain, etc) is almost irrelevant: as long as it is above the 'quality plateau', as it clearly is here, composition and content carry the picture.
NIKKORMAT FTN, 85/1.8 NIKKOR, PATERSON ACUPAN 200. (MARIE MUSCAT-KING)

Envoi – A Sense of Vision

We hope that after reading this book, you will have a better idea of both how to analyse quality, and how to achieve it. As already mentioned, we hope, too, that you will have said, at least once, 'I could do better than that!' – and that you will proceed to do so.

It is, after all, a mistake to try to dazzle the reader with the authors' cleverness and talent. No matter how good an author may be, or how much he or she may know, there will always be readers who know more, and who can achieve more. In a book of this kind, an author can hope for no more than this: that the book should be remembered with affection, and perhaps with some respect, as something which helped the reader to become a better photographer. We, like you, are learning all the time. Where we have learned more than some, it is because we have spent more time on the subject than most; we hope that the fruits of our researches may be useful to you. At the end of it all, though, there is one last point that we would like to reiterate. It is this:

There is a great difference between a technically excellent picture, and one which is a work of art. A work of art transcends technical limitations; it may well incorporate them, or even make a feature of them.

This is a very long way from saying that technique does not matter. There are plenty of self-proclaimed artists whose modest talents would look a great deal better if they paid more attention to technique, and less to originality (or to mere shock value) at any cost. But equally, there are plenty of technicians whose work is flawless, but who rarely, if ever, stray into the realms of art.

This is, in effect, the difference between quality in illustration, and quality in art. Given reasonable access to equipment and materials, the former depends solely on technique, which can be learned. The latter depends only partly on quality, and the better the artist's eye, the more original the artist's vision, the more passion in the artist's soul, the less important the technique becomes. The sole relevance of technique to a great artist is that it may unlock the door to his or her art: it is the realization that 'Hey, I can do this!'

There are, we know, plenty of pictures in this book – and not just the equipment illustrations – that fall short of what we would like. Partly, this is because of the way we earn a living: we have to illustrate various technical points, and we cannot always do so with pictures of the quality we might wish. Partly, too, it is because we are not the artists we would like to be.

There are, however, at least a few pictures in here that remind us of why we take photographs, and give us hope that we may take other good pictures in the future. Look back among your own pictures, and dwell upon your favourites. Ask yourself if there are not others which might have been favourites, if only they had been technically better. If there are: well, get out there, and start shooting!

SUNSET OVER SEA
Cropped to a panorama, this is dramatic and moody. All in, it is dominated by an overly dark foreground. Instead of a Leica with a 35mm lens (f/1.4 Summilux), Roger might have done better to use a 6x17cm camera with a 300mm lens, but this is something we rarely carry with us. Cropping is a compromise, but it may be the only sensible compromise.
FUJI ASTIA.

Index